First published in Great Britain 2006 by Search Press Limited,
Wellwood, North Farm Road, Tunbridge Wells, Kent TN2 3DR

Originally published in France 2005 by Groupe Fleurus

English translation by Rae Walter for First Edition Translations Ltd, Cambridge, England

ISBN-10: 1-84448-194-8
ISBN-13: 978-1-84448-194-1

The authors and the editor particularly wish to thank the button manufacturer CRÉPIN
PETIT for kindly providing the buttons for the jewellery shown on pages 62 to 65 and 70
to 73.

Printed in France by Pollina - n°edition : L40870-A

KATIA RICHETIN AND KARINE MICHEL

SIMPLE BUTTON JEWELLERY

PHOTOGRAPHS : PATRICE RENARD

SEARCH PRESS

CONTENTS

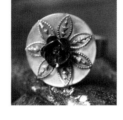
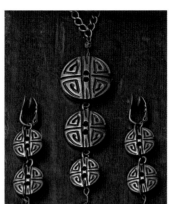
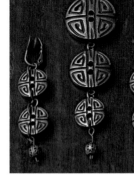
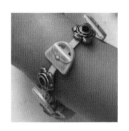

Materials

Buttons and sequins

There is a wide choice of buttons available in haberdashery, fabric and craft shops. Buttons can be attached in various ways, but the ones we have used most frequently are those with two holes. In this book we have devoted a lot of space to mother-of-pearl buttons, also known simply as pearl buttons. Pearl buttons or sequins (natural or dyed) can be mixed in an infinite number of ways to create many beautiful colour combinations.

Beads

Beads come in various colours and materials: glass, crystal, metal, ceramic... Match the colours and finishes (transparent, iridescent, etc.) to the various buttons, imitation gemstones and decorative metal components.

Imitation gemstones

We have used 4 mm imitation gemstones, which come in various colours. Their sparkling facets add a festive note to the jewellery.

Stampings, flowers and dangles

These metal components (copper, brass, silver, etc.) in the form of filigree plaques or miniature objects add an exotic note.

Woollen fabrics

Baize or felt has the useful advantage of not fraying.

Ribbons

Satin or velvet... ribbons come in a wide choice of materials and colours.

Threads

Threads differ in flexibility and thickness. The choice depends on the effect you want to achieve and the kind of project you are working on. Transparent nylon thread of gauge 0.35 mm is perfect for threading seed beads. We have used stretchy nylon thread for rings.

Cotton, rayon or leather cord

These vary in flexibility and thickness. They are especially recommended for making bracelets and necklaces. Flat leather laces can be used for threading large buttons, which can be kept in place with a few dabs of glue.

Rat-tail cord

A silky-effect cord, available in various thicknesses, which we have used here instead of chain for pendants.

Stranded embroidery cottons

Made up of six separable strands, they offer a wide variety of colours and a wonderful sheen.

Copper or brass wire

Copper or brass wire of 0.3 mm gauge is both firm and flexible. It adds a touch of class to rings.

Findings

These are small accessories needed for making and finishing jewellery.

"Knot-hiders", also called calottes or simply necklace ends

These are used to hide the knots when finishing necklaces or bracelets. They also enable you to attach a clasp.

Clasps

Screw clasps, spring clasps, lobster-claw clasps... We prefer the last named, but of course you can choose a different type.

End caps

End caps are used to cover the ends of thicker cords (round or flat) and to attach clasps.

End clamps

These are used as knot-hiders, and make a pretty finish to a necklace or bracelet made of ribbon.

Eyelet pads

These can be glued to the back of a button to enable you to string it.

Fold-over daisy bails

These are small, pliable metal strips with a stem at one end and a hole at the other. They are an attractive way of hanging a sequin, a button or a dangle.

Rings

There are two kinds of rings: jump rings, which can be opened and closed, and solid rings. Different diameters are needed to suit the various buttons.

Head pins and eye pins

Head pins are used to make dangles. Eye pins are used to make articulated jewellery.

Flat pad rings

The pads come in different diameters. They are used as a base on which to glue buttons or felt items.

Earring mounts

You can choose from simple earring wires, shell-motif clips, clips for dangles, or earrings for pierced ears.

Chains

Use a chain with links of a size to suit the piece you are making.

Various mounts and clasps

In this book, we also make use of kilt pins and large hoop earrings, as well as key-rings, hairslides and magnets.

Jewellery pliers

These are easily obtainable from all bead and craft shops.

Flat nose pliers are used for holding small items, opening and closing jump rings and squeezing crimps.

Wire cutters are used for cutting wires or chains.

Round nose pliers are used for making loops in pins.

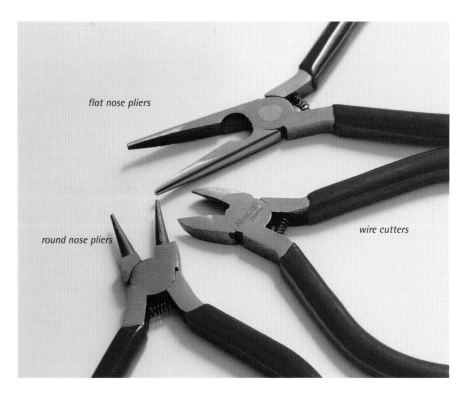

flat nose pliers

round nose pliers

wire cutters

Needles

Beading needles

We have used two kinds of needles.

The classic type, which is long and narrow with a small eye, is particularly suitable for use with seed beads.

The other type, long and flexible, with an eye that runs almost the whole length of the needle, enables you to thread a cotton cord or a leather lace.

Other needles

Embroidery needles have a long eye suitable for embroidery threads.

Sewing needles are used for stitching and for tacking.

Scissors

Dressmaking scissors are needed to cut the various pieces of fabric.

Embroidery scissors, small and with pointed blades, are ideal for very precise cutting.

Pinking shears enable you to cut out shapes with zigzag edges.

Adhesives

Jewellery glue

This enables you to stick non-porous materials together (buttons and metal, for example). It takes about 12 hours to dry.

Tip: To keep the glued item perfectly in position, make sure the pad of the base is horizontal during drying. If it is a ring, you can push the ring part into modelling clay.

Fabric glue

As it dries, invisible fabric glue bonds the pieces of fabric (felt, ribbons and braids).

Miscellaneous

Tape measure, ruler, fabric marking pencil, pins and a pair of compasses.

Advice

Workspace

It is important to have a comfortable, well-lit workspace.

When preparing your work, keep all the various components in small plates or dishes. In that way, you will not run the risk of scattering or losing them.

Adaptable jewellery

While you are working and before you add the finishing touches, we advise you to try on the piece and look in a mirror to see what effect it has. You can check the size and shape and adapt them to suit yourself. These are some of the approximate lengths of the finished pieces (including clasps).

Choker: approximately 40 cm (16 ins).

Small necklace: 50 to 60 cm (20 to 24 ins).

Bracelet: 16 to 20 cm (6¼ to 8 ins), depending on the size of the wrist.

Techniques

Threading a button

Pass the thread through the hole in the button from the bottom upwards (a), then through the second hole (from the top down) (b).

If you encounter any problems (for example, if the cord frays), you can use the flexible beading needle.

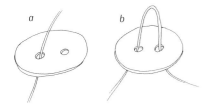

Attaching a clasp

With a calotte

Put a spot of glue in the open calotte (a). Insert the finishing knot, then, using the flat nose pliers, close the two parts together (b). Use a jump ring to attach the calottes to the clasp (c). Attach one or more jump rings to the calotte at the other end.

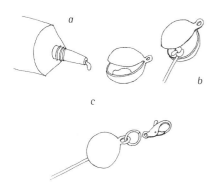

With an end cap

Insert the end of the lace into the end cap, having previously glued the inside. Flatten the two sides slightly with the flat nose pliers, then attach the end cap to the clasp with a jump ring. Do the same at the other end, but attach one or more jump rings instead of a clasp.

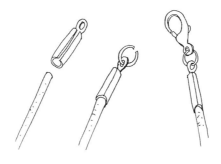

On an end clamp

Glue the inside of the clamp, then insert the ribbon. Using flat nose pliers, close the jaws of the clamp (a). Insert a ring in the small loop and attach this to the clasp (b). Add a chain made of jump rings to the other end.

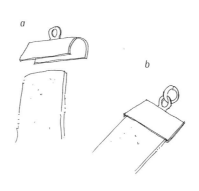

On a chain

Join the last link of the chain to the clasp with a jump ring.

Joining ring

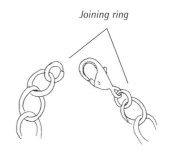

Opening and closing a jump ring

It is easier to do this using two pairs of pliers. It is best to open a ring by twisting it, so as not to distort it. Pull one end of the ring towards you and push the other one away from you. Use the same method to close it again.

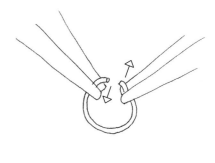

Making a small chain

Small chains are very useful for adjusting the size of some pieces of jewellery. Using this technique, you can make all the chain you need for a bracelet. Simply link jump rings together (a). You can create a variation by alternating rings of two different sizes (b).

Attaching a bail

Pass the stem of the bail through the hole in the button, then through the hole at the other end of the strip (a). Push the end of the stem upwards, cutting a piece off with wire cutters if necessary. Squeeze the whole thing with flat nose pliers (b).

In some cases, the bail can be replaced by two jump rings.

On an eye pin

Follow the same method as on a head pin. Dangles can be linked together to make articulated jewels. In this case, do not completely close the loop of the pin, so that you can link one dangle to another. Finish by closing the loop with the flat nose pliers.

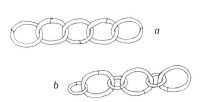

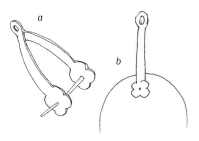

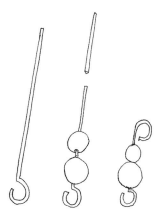

Earrings

Attaching your jewel to a mount

Some earring wires or shell-motif clips have a ring that can be opened. Attach your jewel, then close the ring.

For mounts that do not have rings that open, you will have to use a jump ring to attach your creation.

Dangles

On a head pin

Thread the beads of your choice on to a head pin. Using wire cutters, cut the pin off about 1 cm (½ in) above the last bead (a). Place the round nose pliers at the top of the pin and roll it around them to form a loop (b).

Sewing and embroidery stitches

Running stitch

This is the simplest sewing stitch. Thread a needle. Make a knot at the end of the thread. Stitch along a straight line with even stitches. Starting underneath the work, bring the needle out at A, pass it back through at B and come out again at C. Pull the thread to get the correct tension. Tacking is done in the same way. It is used to keep pieces of fabric or ribbon temporarily in place and is later removed.

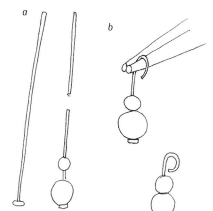

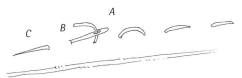

Blanket stitch

This stitch is used to give a neat straight or curved edge. It enables you to strengthen edges and gives them an attractive finish. Bring the needle out at A (edge of the cloth), take it back through at B and come out again at C, passing the needle over the thread coming from A. Pull gently to align the thread properly with the edge. Continue in the same way, spacing the stitches evenly.

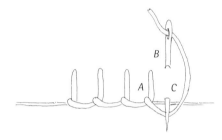

Making a fuxico

A fuxico is a small cushion of gathered fabric. In Brazil (where "fuxico" means "whispering"), women meet to work at their sewing together, while whispering confidences to one another. They do this while making bedspreads, cushions, clothes etc.

Cut a circle of fabric (draw round a template of appropriate diameter with a fabric marker). With a thread to match the fabric, sew all the way round the circle in running stitch 5 mm (¼ in) from the edge (a). Pull the thread gently, flattening and evening out the gathers, making a small gathered cushion (b). Make a few tight stitches at the centre to hold the gathers in place.

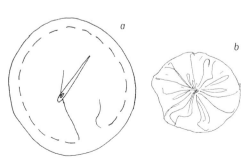

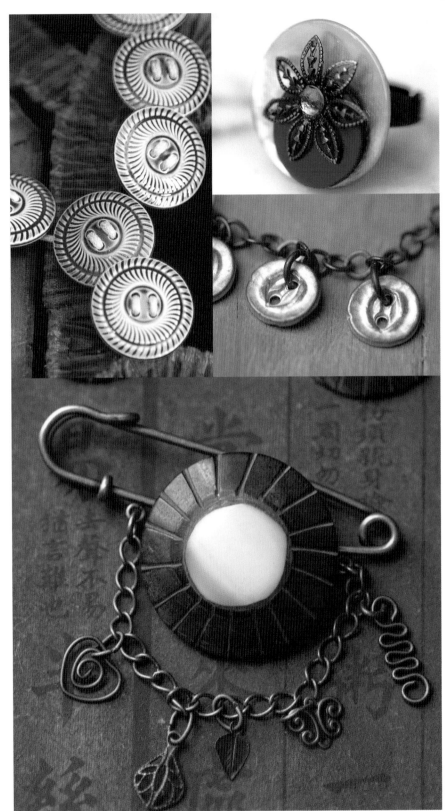

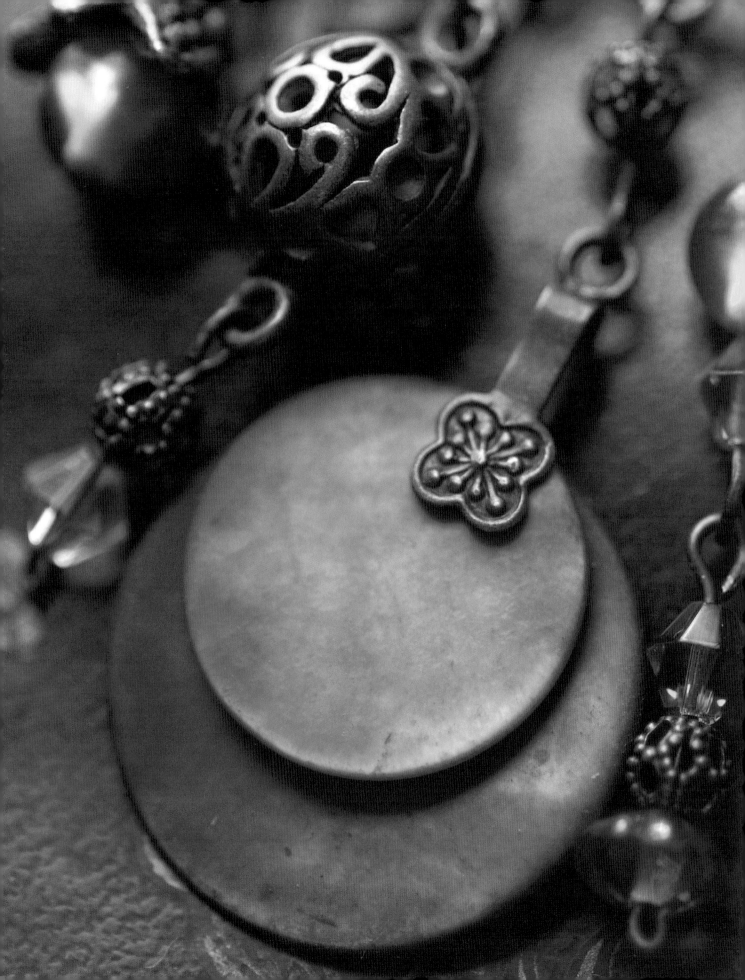

Mother-of-Pearl Jewellery

Mother-of-pearl shells open up like a treasure chest, revealing the unexpected glint of jewellery. Plain or sparkling, the purity of mother-of-pearl gives that special touch to all your outfits. Glowing like the setting sun, sharp as acid drops or as changeable as a stormy sky, pearl buttons offer you a wealth of subtle shades.

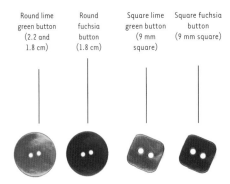

Round lime green button (2.2 and 1.8 cm) | Round fuchsia button (1.8 cm) | Square lime green button (9 mm square) | Square fuchsia button (9 mm square)

Buttons on Buttons

Bracelet

Materials

Bracelet

Round lime green pearl buttons:
3 x 2.2 cm and 2 x 1.8 cm

Round fuchsia pearl buttons: 3 x 1.8 cm

9 mm square pearl buttons: 3 in lime green and 2 in fuchsia

2 brass calottes

1 brass lobster-claw clasp

2 x 5 mm brass jump rings

Beading needle with flexible eye

35 cm (14 ins) rayon cord in fuchsia

Flat nose pliers

Jewellery glue

Ring

Round lime green pearl button:
1 x 2.2 cm

Round fuchsia pearl button: 1 x 1.8 cm

9 mm square pearl button: 1 in lime green

3 seed beads in old gold

1 brass ring base with a pad about 1.5 cm diameter

20 cm (8 ins) nylon thread

Jewellery glue

1 Prepare and lay out the buttons in the order you are going to string them (a).

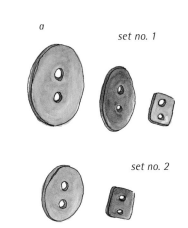

a

set no. 1

set no. 2

2 Thread the cord through the beading needle and slide the needle to the middle of the cord.

3 Take the first set of buttons and align all the holes in the buttons. Using the beading needle, pass the thread from below through one line of holes then back through the other line from above (b).

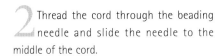

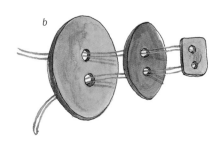

b

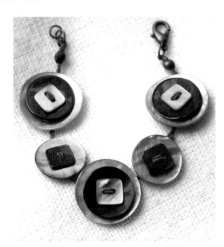

4 Slide the first set of buttons to about 6 cm (2½ ins) from the end of the cord. Do the same with the other set, alternating sets 1 and 2 and sliding them close together.

5 To finish, make a knot at each end of the cord, adjusting the length to fit your wrist. Attach the calottes and the clasp (see page 9) (c).

c

Ring

 Place the three buttons one on top of the other, aligning the holes (a).

a

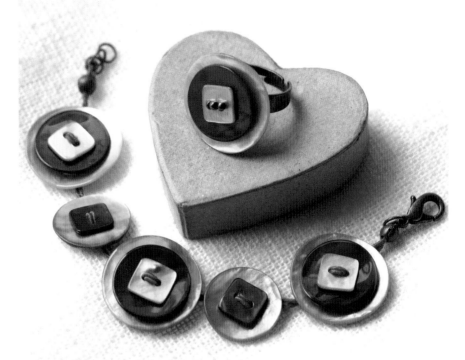

Pass the nylon thread from below through one line of holes. String the three seed beads, then pass the thread through the second line of holes from above (b). Make a very tight double knot and cut off the remaining thread. Slide the knot into one of the holes underneath the buttons.

b

Glue the pad of the ring and place the set of buttons on it, carefully centred (c). Leave to dry overnight in a horizontal position (see page 8).

c

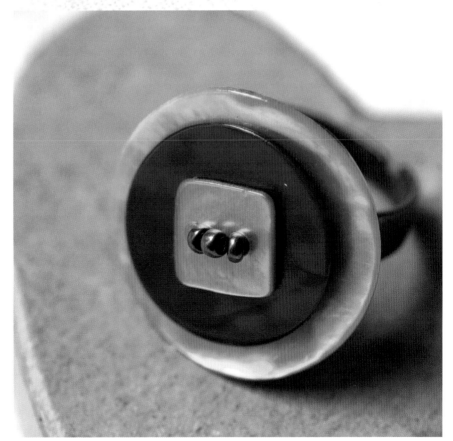

Round lime
green pearl
button
(2.2 cm)

Round
fuchsia
pearl sequin
(1.5 cm)

Asymmetric Buttons

Bracelet

M a t e r i a l s

Bracelet

1 x 2.2 cm round pearl button in lime green

1 x 1.5 cm round pearl sequin in matt fuchsia

1 x 4 mm diameter green imitation gemstone

1 x 3 cm long brass arabesque-style filigree stamping

4 brass beads 3 mm square

2 oblong brass beads 1.8 cm long

2 brass calottes

1 brass lobster-claw clasp

2 x 5 mm brass jump rings

Beading needle with flexible eye

50 cm (20 ins) fine rayon cord in fuchsia

Jewellery glue and flat nose pliers

Ring

1 x 2.2 cm round pearl button in lime green

1 x 1.5 cm round pearl sequin in matt fuchsia

1 x 4 mm diameter green imitation gemstone

1 x 1.7 cm diameter chased brass flower

1 brass ring base with a pad about 1.5 cm diameter

Jewellery glue

1 Start by gluing the fuchsia sequin to the green button, then glue the imitation gemstone over the hole in the sequin (a). Leave to dry for about 1 hour.

2 Cut 2 x 25 cm (10 ins) lengths of cord. Thread one piece through each end of the stamping and fold it in half.

3 Pass the double thread through the eye of the beading needle. String 1 square bead, 1 oblong bead and another square bead, and finish with a knot. Do the same on the other side.

4 Try the bracelet on so you can adjust the length to fit your wrist. Make a knot at each end of the cord and attach the calottes and the clasp (see page 9).

5 To finish, glue the set of buttons to the centre of the stamping. Leave to dry overnight in a horizontal position (see page 8).

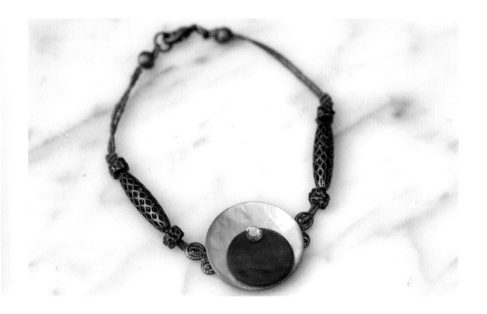

Ring

1 Glue the fuchsia sequin to the button so that it covers the holes (a).

2 Put a spot of glue on the back of the brass flower and position it over the hole in the sequin. Then glue the gemstone in the centre of the flower (b).

3 To finish, glue the whole motif to the pad of the ring and leave to dry overnight in a horizontal position (see page 8) (c).

a

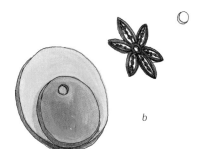

b

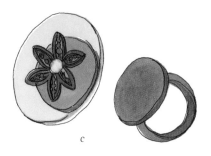

c

Round natural
mother-of-
pearl sequins
(2.2 and 3 cm)

Round matt
red pearl
button
(1.5 cm)

Festive Glints

Materials

Necklace

1 x 1.5 cm round pearl button in matt red

1 x 3 cm round natural pearl sequin

1 x 4 mm diameter crystal imitation gemstone

1 x 1.7 cm diameter chased brass flower

2 brass calottes

1 brass lobster-claw clasp

1 brass bail

3 x 5 mm brass jump rings

45 cm (18 ins) rayon cord in dark red

Flat nose pliers

Jewellery glue

Earrings

2 x 1.5 cm round pearl buttons in matt red

2 x 2.2 cm round natural pearl sequins

2 x 3 mm diameter crystal imitation gemstones

2 x 1.7 cm diameter chased brass flowers

2 brass bails

French clips with shell motif in brass

Flat nose pliers and wire cutters

Jewellery glue

Necklace

1 Position the button on the sequin and the brass flower on top, so that the holes match up (a).

a

2 Fold the bail in half (see page 10) and pass the stem through the flower, the top hole of the button and the hole in the sequin. Squeeze tightly and turn up the end of the stem (b).

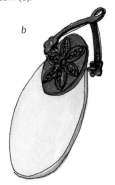

b

3 Attach a jump ring to the ring on the bail (see page 9) and thread the cord through it (c).

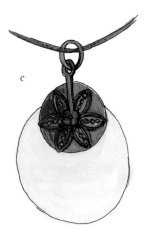

c

4 Check the length of the necklace. Make a knot at each end and attach the calottes and the clasp (see page 9).

5 To finish, glue the gemstone in the centre of the flower and leave to dry for 2 hours.

Earrings

1 Assemble the sequins, buttons and flowers as for the necklace (see figures a and b of the necklace).

2 Attach the ring of the bail to the earring (see page 10) (a).

3 Glue the gemstone in the centre of the flower and leave to dry for 2 hours.

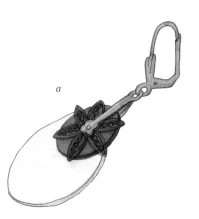

a

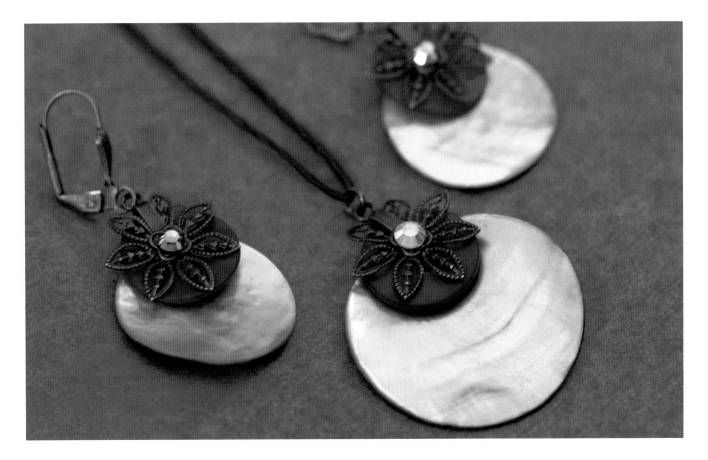

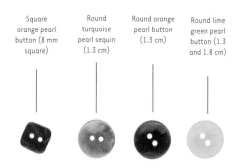

Square orange pearl button (8 mm square)

Round turquoise pearl sequin (1.3 cm)

Round orange pearl button (1.3 cm)

Round lime green pearl button (1.3 and 1.8 cm)

Acid Drops

Materials

Bracelet

1.3 cm round pearl buttons: 3 in turquoise, 3 in orange and 3 in lime green

1 copper-coloured lobster-claw clasp

26 x 5 or 6 mm copper-coloured jump rings

2 x 3 mm copper-coloured jump rings

Flat nose pliers

Ring

1 x 1.8 cm round pearl button in lime green

1 x 1.3 cm round pearl button in turquoise

1 x 8 mm square pearl button in orange

1 x 5 mm oval bead in copper-colour

40 to 45 copper-coloured seed beads

Nylon thread

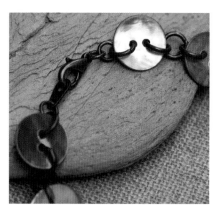

Bracelet

1 Using the pliers, attach 2 jump rings to each button (see page 9) (a).

a

2 Link the buttons by inserting a jump ring between each one, alternating the colours, and continue so they form a small chain (b).

b

3 Attach the chain to the clasp with a small jump ring (see page 9) (c).

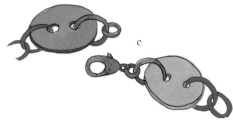

c

Ring

1 Position the orange, turquoise and green buttons together, so the holes match up.

2 Thread 30 cm (12 ins) nylon thread through one of the sets of holes from below. String the oval bead, then pass the thread through the second set of holes from above (a).

a

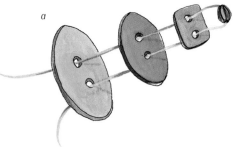

3 Make the ring by stringing about 20 seed beads on each strand (b).

b

4 Cross the strands in a seed bead in the middle of the ring. Make a double knot and "weld" it in the heat of a flame.

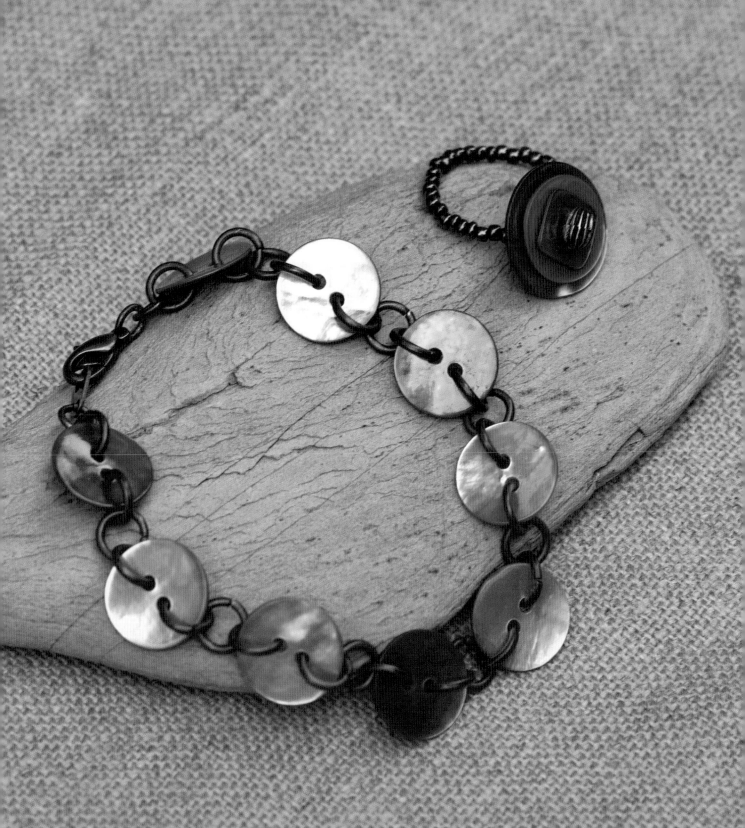

Fish-shaped natural mother-of-pearl sequin (2.5 cm)

Round mother-of-pearl sequin (1.2 cm)

Beachcombings

Bracelet

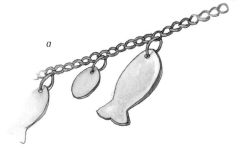

Materials

Bracelet

2 x 1.2 cm round natural mother-of-pearl sequins

3 x 2.5 cm long fish-shaped natural mother-of-pearl sequins

15 to 20 cm (6 to 8 ins) brass chain with large links

1 brass lobster-claw clasp

7 x 3 or 4 mm brass jump rings

Flat nose pliers

Earrings

2 x 1 cm round natural mother-of-pearl buttons

2 x 2.5 cm long fish-shaped natural mother-of-pearl sequins

8 x 3 mm brass jump rings

2 x 5 mm long oval brass rings

Brass earring wires

Flat nose pliers

1 Flatten out the chain in front of you. Using a jump ring (see page 9), attach a fish-shaped sequin to the chain 4 cm (1½ ins) from one end.

2 Using jump rings, attach in sequence every 1.5 cm (¾ in) 1 round, 1 fish, 1 round and 1 fish sequin (a).

3 Finish the bracelet by attaching the chain to the clasp with a jump ring at each end (see page 9) (b).

Earrings

1 Using pliers, attach 2 jump rings to each button, then attach 1 oval jump ring to the fish-shaped sequins (a).

2 Link the button to the sequin with a jump ring, then attach the whole drop to the earring wire with a jump ring (b).

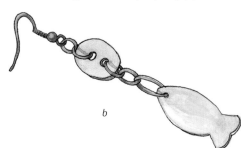

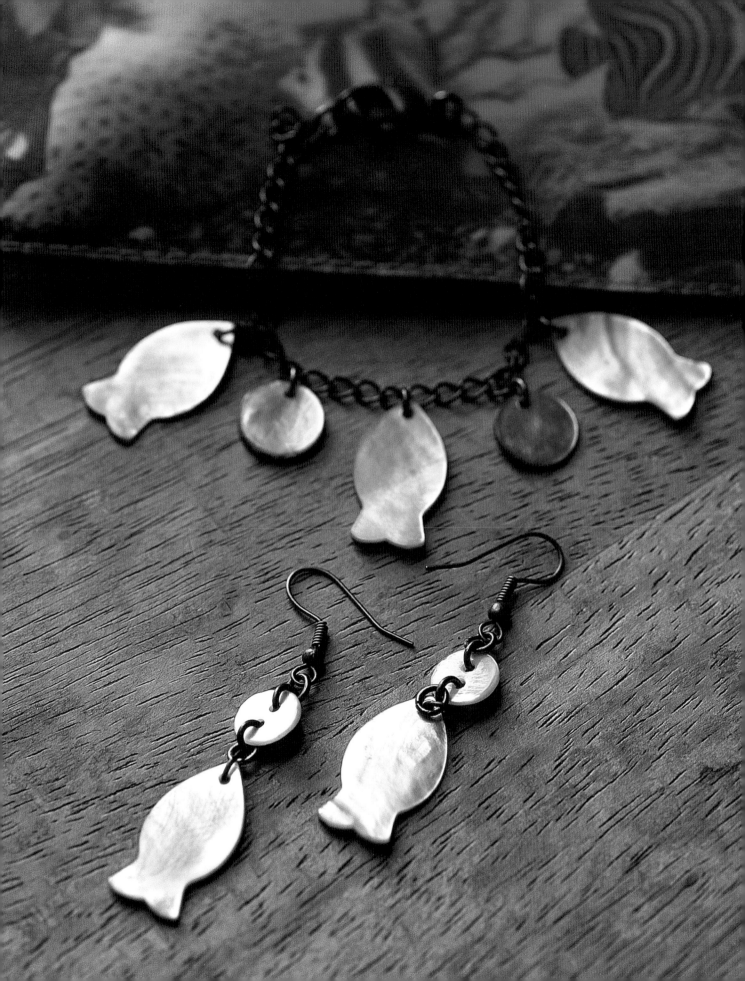

Turquoise Shimmer

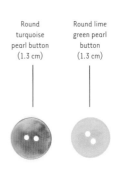

Round turquoise pearl button (1.3 cm)

Round lime green pearl button (1.3 cm)

Necklace

Materials

Necklace

2 x 1.3 cm round pearl buttons: 1 in lime green and 1 in turquoise

1 x 8 mm turquoise glass bead

1 x 6 mm turquoise ceramic bead

1 x 3 mm chased copper bead

1 copper-coloured head pin

2 copper-coloured calottes

1 copper-coloured lobster-claw clasp

Copper-coloured jump rings: 5 x 5 mm and 2 x 3 mm

50 cm (20 ins) turquoise rayon cord

Flat nose pliers, round nose pliers and wire cutters

Jewellery glue

Earrings

4 x 1.3 cm round pearl buttons: 2 in lime green and 2 in turquoise

2 x 3 mm chased copper beads

2 copper-coloured head pins

Copper-coloured jump rings: 8 x 5 mm and 6 x 3 mm

Copper-coloured earring wires

Flat nose pliers, round nose pliers and wire cutters

1 Using flat nose pliers, attach a 5 mm jump ring to the turquoise button (see page 9) and 2 jump rings to the green button. Join them together with a 3 mm jump ring (a).

a

2 Next, prepare the dangle of beads. On a head pin, string the glass bead, the ceramic bead and finally the chased metal bead. Cut off the head pin 1 cm (1/2 in) above the last bead and form a loop, using the round nose pliers (b).

b

3 Attach the dangle by passing a 3 mm jump ring through the loop of the dangle and the ring of the green button (c).

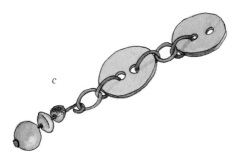

c

4 To thread the cord through the turquoise button, fold it in half and insert the loop through the hole in the button from underneath. Thread both ends of the cord through the loop and pull to tighten the cord around the button (d).

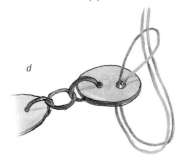

d

5 Adjust the length of the necklace. Make a knot at each end and attach the calottes and the clasp (see page 9).

Earrings

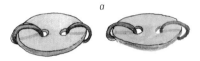

1 Start by attaching 2 x 5 mm jump rings to each button, using flat nose pliers (see page 9) (a).

a

2 Join 1 green button and 1 turquoise button together using a 3 mm jump ring (b).

b

3 To make the dangle, string 1 copper bead on a head pin. Cut the pin off at 1 cm (½ in) above the bead and form a loop using the round nose pliers. Attach the dangle to the turquoise button using a 3 mm jump ring (c).

c

4 Finally, hang the button drop from the earring wire using a 3 mm jump ring (d).

d

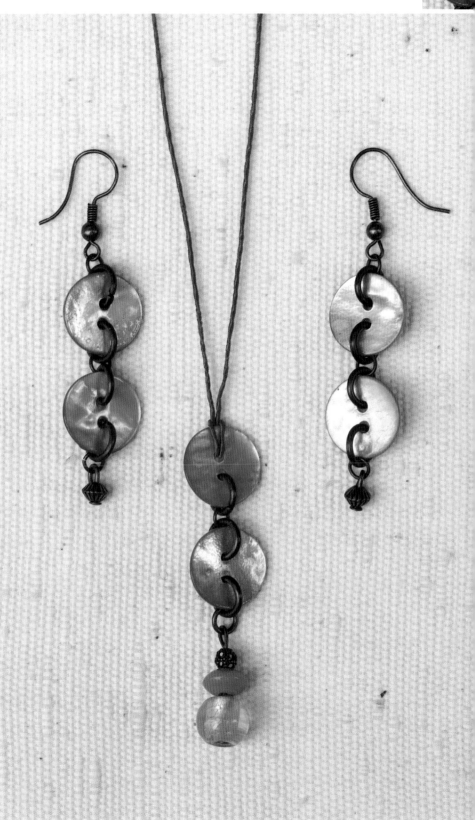

Stormy Hearts

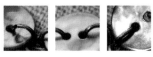

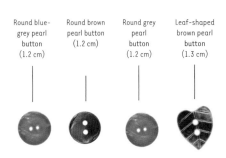

Round blue-grey pearl button (1.2 cm)

Round brown pearl button (1.2 cm)

Round grey pearl button (1.2 cm)

Leaf-shaped brown pearl button (1.3 cm)

Materials

Earrings

2 x 1.2 cm round blue-grey pearl buttons

2 x 1.3 cm long leaf-shaped brown pearl buttons

2 copper-coloured heart-shaped dangles

Copper-coloured jump rings: 2 x 7mm and 10 x 5 mm

Copper-coloured French clips with shell motif

Flat nose pliers

Ring

1 x 2.3 cm round brown pearl button

1 x 1.3 cm long leaf-shaped brown pearl button

1 x 4 mm blue-grey bicone

2 seed beads in old gold

1 copper-coloured ring base with 1 cm diameter pad

Nylon thread

Jewellery glue

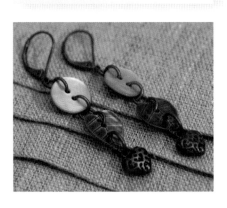

Earrings

1 Using flat nose pliers, insert a 5 mm jump ring into each of the holes in a blue-grey button (see page 9) and a 5 mm jump ring in the upper hole in a leaf-shaped button (a).

2 Next, open a 7 mm jump ring, insert it in the lower hole of the leaf-shaped button, attach the heart-shaped dangle to it and close the ring (b).

3 Link the blue-grey button and the leaf-shaped button with a 5 mm jump ring. Attach the whole drop to the ring of the French clip with a 5 mm jump ring (c).

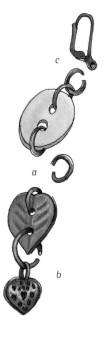

Ring

1 Position the leaf-shaped button on the round button, matching the holes.

2 Pass the nylon thread through the upper holes in the buttons from below. String the beads (1 seed bead, 1 bicone and another seed bead), then pass the thread through the lower holes. Make a very tight double knot and slide it into one of the holes underneath the last button. Cut the ends off level with the knot (a).

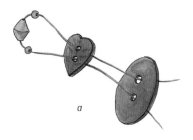

3 Glue the pad of the ring base and position the motif on it. Leave to dry overnight in a horizontal position (see page 8).

Necklace

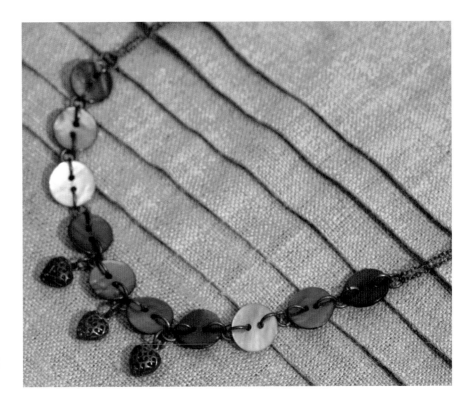

Materials

Necklace

4 x 1.2 cm round brown pearl buttons

3 x 1.2 cm round blue-grey
pearl buttons

3 x 1.2 cm round grey pearl buttons

3 copper-coloured heart-shaped dangles

2 narrow copper chains 28 to 30 cm
(11 to 12 ins) long

2 copper-coloured calottes

1 copper-coloured lobster-claw clasp

Copper-coloured jump rings: 27 x 5mm
and 9 x 3 mm

Jewellery glue

Flat nose pliers

1 Using the flat nose pliers, place a 5 mm jump ring in each hole in the buttons (see page 9) (a).

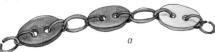

a

2 Using a 3 mm jump ring each time, join them all together in the following sequence: 1 brown, 1 grey, 1 blue, etc. (b).

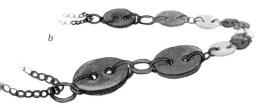

b

3 Attach a 5 mm jump ring to each end to thread the chains through (b).

4 Adjust the length of the necklace and attach the calottes to each end with a spot of glue (see page 9). Join them to the clasp with jump rings (c).

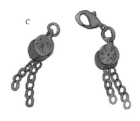

c

5 Finish by attaching the heart-shaped dangles. Insert a 5 mm jump ring through the ring on the dangle and attach one to each of the rings linking the 4 central buttons (d).

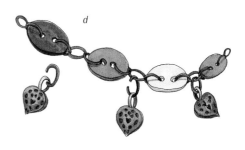

d

Round matt pink pearl button (2.2, 1.7 and 1.2 cm)

Round matt sky blue pearl button (1.7 and 1.2 cm)

Materials

Ring

1 x 2.2 cm round matt pink pearl button

1 x 1.7 cm round matt sky blue pearl button

1 x 1.4 cm diameter brass flower

1 brass ring base with 1 cm diameter pad

Jewellery glue

Earrings

4 round matt pink pearl buttons:
2 x 1.7 cm and 2 x 1.2 cm

2 x 1.2 cm round matt sky blue pearl buttons

2 x 1.4 cm diameter brass flowers

2 brass bails

Brass jump rings: 4 x 6 mm and 2 x 4 mm

French clips with flat pads in brass

Jewellery glue

Flat nose pliers

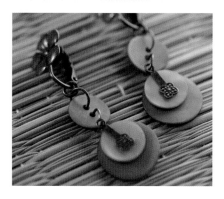

Soft Colours

Ring

1 Glue the blue button on to the pink button, then glue the metal flower to the blue button (a). Leave to dry for 1 hour.

a

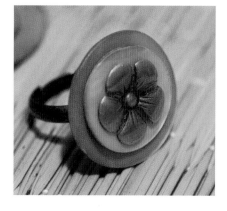

2 Glue the set of buttons to the pad of the ring base (b) and leave to dry overnight in a horizontal position (see page 8).

b

Earrings

1 Position 1 blue button on a 1.7 cm pink button (a). Keep them in place with a bail, by passing the stem through the lower hole of the blue button and the upper hole of the pink button (see page 10). This will give you an asymmetric effect and you can hide the upper hole of the blue button under the bar of the bail. Squeeze the bail tightly.

a

2 Insert a 6 mm jump ring through the ring of the bail and the lower hole in a 1.2 cm pink button to link them together.

3 Insert a 6 mm jump ring through the upper hole in the small pink button.

4 Attach the drop to the earring mount by adding a 4 mm jump ring (b).

b

5 Glue a metal flower on to the pad of the earring mount. Leave to dry overnight.

Materials

Necklace

1 x 2.2 cm round matt pink pearl button

2 x 1.2 cm round matt pink pearl buttons

3 round matt sky blue pearl buttons:
2 x 1.7 cm and 1 x 1.2 cm

2 oblong chased brass beads 2 cm long

3 oval brass beads 5 mm long

2 brass calottes

1 brass lobster-claw clasp

2 x 6 mm brass jump rings

Beading needle with flexible eye

85 cm (34 ins) rayon cord in fuchsia

Jewellery glue

Flat nose pliers

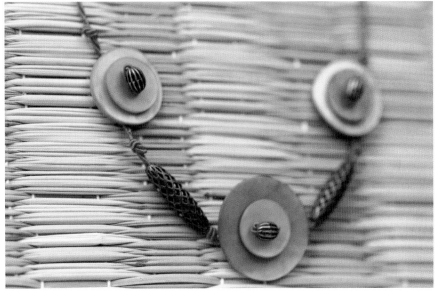

Necklace

1 Cut the cord into two equal pieces. Thread both together through the beading needle.

2 Thread the cords through the 2.2 cm pink button, then the 1.2 cm blue button and finally through an oval bead and back through both buttons (a). Slide this motif along to the middle of the cord. Make a knot on each side, at the edges of the pink button.

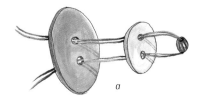

a

3 String an oblong bead on both strands on either side of the motif. Make knots in the cord to prevent the beads from moving, but not too close to them (b).

b

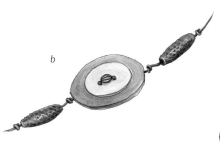

4 On each side of the oval beads, thread the cords through a 1.7 cm blue button, then a 1.2 cm pink button and finally an oval bead, then back through the buttons. Make a knot at the edge of each blue button.

5 Adjust the necklace to fit your neck (cut the cords if necessary). Make a knot at each end. Attach the calottes, the jump rings and the lobster-claw clasp (see page 9). Then turn your necklace over and fix the cords in place with a spot of glue on the back of the three sets of buttons (c). Leave to dry overnight in a horizontal position (see page 8).

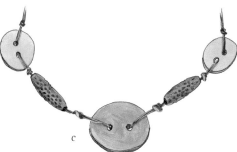

c

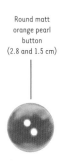

Round matt
orange pearl
button
(2.8 and 1.5 cm)

Sunset

Materials

Ring

Lime green and khaki felt

1 x 1.5 cm round matt orange
pearl button

1 x 5 mm round orange bead

1 brass ring base with 1 cm diameter pad

Orange rayon cord

Beading needle with flexible eye

Jewellery glue

Pinking shears

Necklace

Lime green and khaki felt

1 x 2.8 cm round matt orange
pearl button

1 x 5 mm round orange bead

Brass jump rings: 1 x 8 mm and 2 x 6 mm

2 brass end caps

1 brass bail (or 2 x 5 mm jump rings)

1 brass lobster-claw clasp

Beading needle with flexible eye

About 42 cm (16½ ins) rat-tail cord

Orange rayon cord

Pinking shears

Wire cutters and flat nose pliers

Ring

1 Using some pinking shears, cut a rectangle 3 x 2.5 cm (1¼ x 1 in) of khaki felt and a 2 cm (¾ in) square of lime green felt. Position the green square centrally on the khaki rectangle.

2 Using rayon cord, sew the button with the bead on top of it in the centre of the felt rectangles. Make a tight knot at the back.

3 Glue this motif to the pad of the ring base and leave to dry overnight in a horizontal position (see page 8) (a).

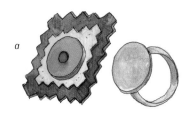

a

Necklace

1 Using pinking shears, cut a rectangle 4 x 4.5 cm (1½ x 1¾ in) of khaki felt. Cut a rectangle 3.2 x 3.7 cm (1¼ x 1½ in) of lime green felt. Place the green rectangle centrally on the khaki rectangle.

2 Using rayon cord, sew the button with the bead on top of it in the centre of the felt rectangles. Make a tight knot at the back.

3 Attach the bail by passing the stem through the centre of the top edge of the khaki rectangle (see page 10). You can also use 2 jump rings instead of the bail (b).

4 Attach the 8 mm jump ring to the ring of the bail. Thread the rat-tail cord through the ring. Adjust the necklace to the desired length, and finish by attaching the end caps, the jump rings and the clasp (see page 9) (c).

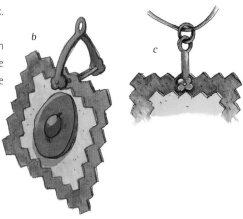

b

c

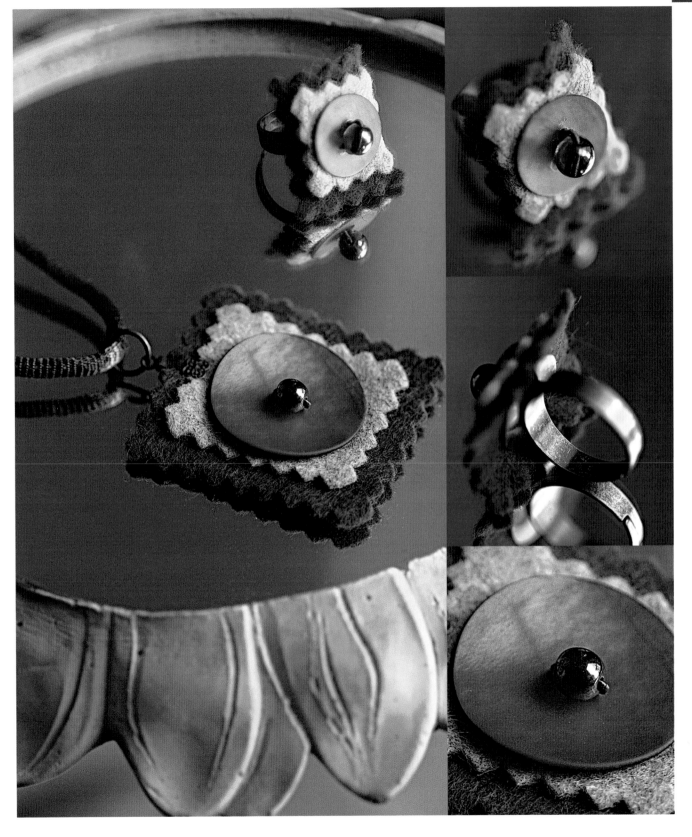

Inspiration from the East

Round
turquoise
pearl sequins
(2 and 1.4 cm)

Round bottle
green pearl
sequins
(2 and 1.4 cm)

Materials

Earrings

2 x 2 cm turquoise pearl sequins

2 x 1.4 cm bottle green pearl sequins

2 x 4 mm turquoise bicones

2 x 4 mm blue faceted beads

2 x 3 mm bottle green cube beads

6 mm round beads: 2 in lime green and
2 in turquoise

2 x 3 mm filigree brass beads

2 x 1.4 cm long brass teardrop dangles

4 brass head pins

4 x 6 mm brass jump rings

1 pair large hoops with 3 rings for
attaching dangles

Brass bead and ring screw earring
mounts with rings for attaching dangles

Round nose pliers, flat nose pliers and
wire cutters

Earrings

1 Make 2 of each of the following
dangles (see page 10). On one head pin,
string 1 lime green bead, 1 filigree bead and
1 faceted bead. Form a loop using the round
nose pliers. On the other head pin, string 1
round turquoise bead, 1 lime green cube and
1 turquoise bicone and make a loop (a).

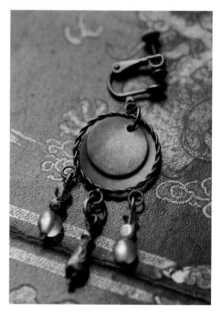

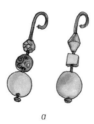

a

2 For each earring, link 1 turquoise sequin
and 1 green sequin, using a 6 mm jump
ring. Insert the top ring of the hoop into the
jump ring (b).

3 Hang the first dangle from the first of
the rings on the hoop. Using a 6 mm
jump ring, hang the teardrop dangle from the
second ring on the hoop. Hang the second
dangle from the last ring on the hoop (c).

4 Attach the hoop to the ring on the earring
mount (see page 10).

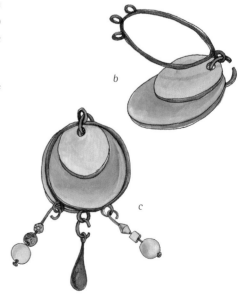

b

c

Brooch

Materials

Brooch

Pearl sequins: 1 x 2 cm in bottle green and 1 x 1.4 cm in turquoise

4 mm bicones: 3 in turquoise and 1 in lime green

2 x 3 mm lime green cube beads

6 mm round beads: 2 in lime green and 1 in turquoise

1 x 4 mm blue faceted bead

1 x 6 mm blue-green rondelle bead

Round filigree brass beads: 3 x 3 mm and 1 x 1 cm

2 x 8 mm long brass leaf-shaped dangles

2 x 6mm brass bell caps

2 brass head pins and 3 brass eye pins

1 brass bail (or 2 x 5 mm jump rings)

Brass jump rings: 2 x 4 mm and 1 x 5 mm

1 brass safety-pin brooch with 7 rings

Round nose pliers, flat nose pliers and wire cutters

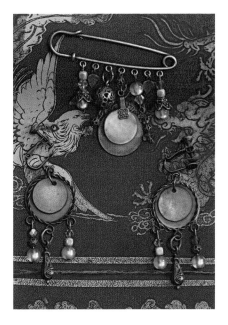

1 Make the dangles (see page 10). On one head pin, string 1 round lime green bead, the bell cap, 1 turquoise bicone and lastly 1 lime green cube. Make a loop using the round nose pliers (a).

2 On an eye pin, string 1 turquoise bicone, then a 3 mm brass filigree bead. Cut off the pin and form a loop. Using the remains of the pin, make a loop, string the 1 cm filigree bead and make another loop. Link these two dangles together (see page 10) (b).

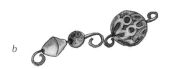

3 On an eye pin, string 1 small 3 mm filigree bead and make a second loop, but do not close it completely (c).

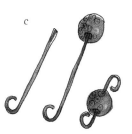

4 Position the two sequins one on top of the other. Attach the bail (page 10). Link the ring on the bail to the loop of the dangle that was not fully closed (d).

5 On an eye pin, string the blue-green rondelle bead, the last filigree bead and the lime green bicone. Cut off the pin and form a loop. Using the remains of the pin, make the first loop. String 1 turquoise bicone and 1 round lime green bead and make the second loop. Link these two dangles (e).

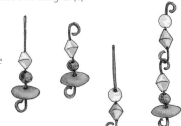

6 On the last head pin, string the round turquoise bead, 1 bell cap, 1 lime green cube and the faceted bead. Make a loop.

7 In sequence: attach the first dangle to the first ring on the brooch. Attach 1 leaf-shaped dangle to the second ring with a 4 mm jump ring. Attach the second dangle to the third ring with a 5 mm jump ring. Attach the sequin dangle to the fourth ring. Attach the fourth dangle to the fifth ring. Hang the second leaf-shaped dangle from the sixth ring. Finally, attach the fifth dangle to the last ring.

Velvet Elegance

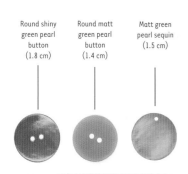

Round shiny green pearl button (1.8 cm)

Round matt green pearl button (1.4 cm)

Matt green pearl sequin (1.5 cm)

Materials

Earrings

2 x 1.5 cm matt green pearl sequins

2 x 3 mm black imitation gemstones

2 x 1.8 cm diameter chased brass flowers

French clips with pads in brass

Jewellery glue

Ring

1 x 1.8 cm shiny green round pearl button

1 x 1.8 cm diameter chased brass flower

1 x 7 mm diameter black metal rose

Brass ring base with 1 cm diameter pad

Jewellery glue

Earrings

1 Glue a chased flower on a sequin, positioning the flower's centre over the hole in the sequin. Glue a gemstone in the centre of the flower (a). Leave to dry for 1 hour.

2 Glue this motif to the pad of the earring mount and leave to dry overnight.

Ring

1 Glue the button, the chased flower and the black rose one on top of the other on to the pad of the ring (a). Leave to dry overnight in a horizontal position (see page 8).

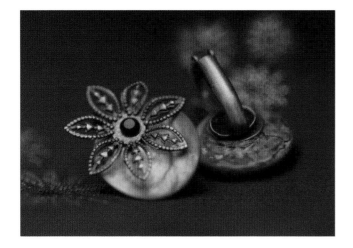

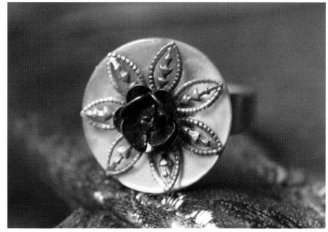

Materials

Bracelet

2 x 1.4 cm round matt green pearl buttons

1 x 1.8 cm round green pearl button

2 x 4 mm black bicones

8 seed beads in old gold or bronze

1 x 1.8 cm diameter chased brass flower

1 x 7 mm diameter black metal rose

15 to 18 cm (6 to 7 ins) black ribbon with picot edging 1.2 cm (1/$_2$ in) wide

15 to 18 cm (6 to 7 ins) green velvet ribbon 1 cm (1/$_2$ in) wide

2 brass end clamps 1.8 cm (3/$_4$ in) wide

1 brass lobster-claw clasp with ring

2 x 3 mm brass jump rings

Nylon thread

Fabric glue and jewellery glue

Beading needles

Flat nose pliers

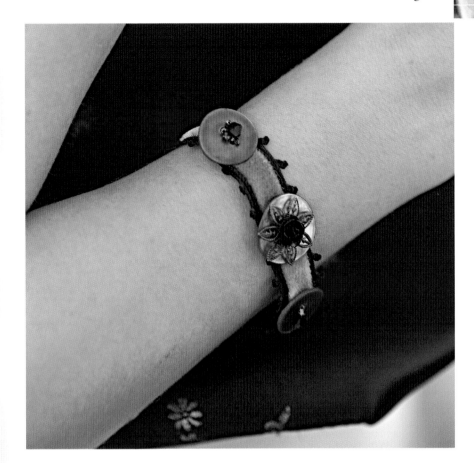

Bracelet

1 To sew the central motif, pass the nylon thread from below through one hole in the large green button, then through the hole in the brass flower. To finish, pass the thread through the hole in the black rose, then through 1 seed bead and back through the rose, the brass flower and the second hole in the button (a).

2 At 1 cm (1/$_2$ in) on each side of the first motif, sew the two matt green buttons, stringing 2 seed beads, 1 bicone and 2 more seed beads on each one (a).

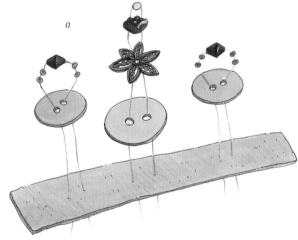

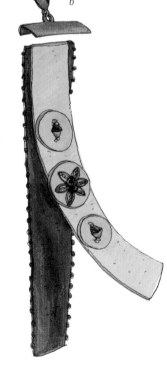

3 Put a line of fabric glue along the entire length of the black ribbon. Lay the green velvet ribbon on it (b). Leave to dry for 1 hour.

4 To finish, attach the end clamps, the jump rings and the lobster-claw clasp (see page 9) (b).

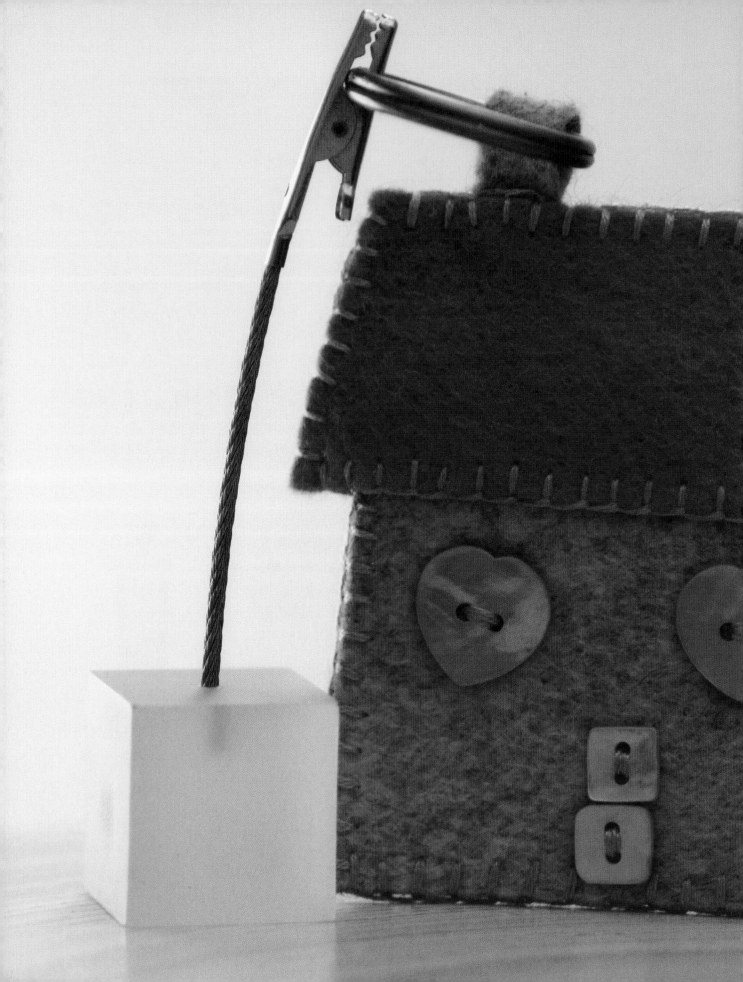

Accessory Stories

For all of these accessories, the feel is soft and satiny. Everyday objects acquire an unexpected allure, delicately highlighted with buttons. A matching hairslide and ring, a belt with its own clutch bag, a key-ring as soft as a baby's blanket – let these accessories tell you their own stories.

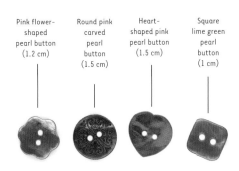

Pink flower-shaped pearl button (1.2 cm)

Round pink carved pearl button (1.5 cm)

Heart-shaped pink pearl button (1.5 cm)

Square lime green pearl button (1 cm)

Soft Surroundings

House Key-ring

M a t e r i a l s

House

Wool felt in old rose and lime green

2 x 1.5 cm heart-shaped pink pearl buttons

2 x 1 cm square lime green buttons

1 brass key-ring

Stranded embroidery cotton in old rose

Embroidery needle

Hairslide

Wool felt in old rose and lime green

1 x 1.5 cm round pink carved pearl button

2 x 1.2 cm heart-shaped pink pearl buttons

1 oval brass filigree stamping 3.5 x 2.5 cm

1 x 6 mm long oval brass bead

2 x 4 mm round filigree brass beads

1 x 8 cm hairslide base

Nylon thread

Fabric glue

Jewellery glue

Embroidery needle

1 Cut 2 roof shapes out of old rose felt and 2 house shapes out of lime green felt (see template, page 78). Cut a strip of green felt 4 x 1 cm (1½ x ½ in).

2 Sew the buttons on to one thickness of the body of the house, using 3 strands of embroidery thread. Use the heart-shaped buttons for the windows and the two square buttons for the door, as shown on the template (a).

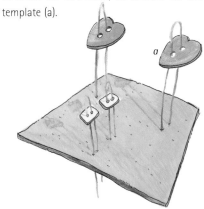

a

3 Place the two main parts of the house together and join using blanket stitch (see page 11), with 3 strands of embroidery thread. Start at the top left corner and continue until 1 cm (½ in) from the top right (b).

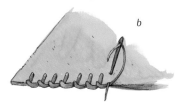

b

4 Sew the two parts of the roof together using blanket stitch. Start at the bottom right corner and continue until 2 cm (¾ in) from the top left. Fold the strip of green felt over the key-ring and insert it between the roof layers, 1 cm (½ in) from the left edge. Secure the key-ring loop on both sides by continuing the blanket stitch to the second bottom corner of the roof (c) and blanket stitching the other side of the loop.

c

5 Insert the top 1 cm (½ in) of the body of the house between the two layers of the roof. Join them together by blanket stitching round both sides of the bottom edge of the roof (d).

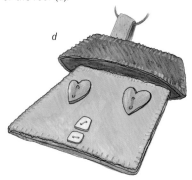

d

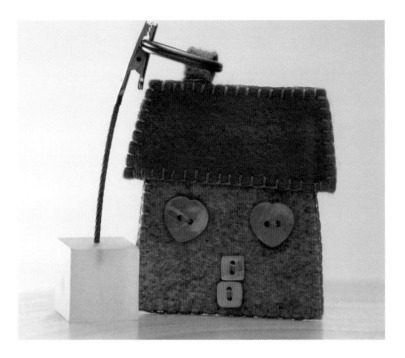

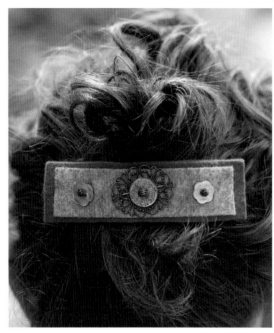

Hairslide

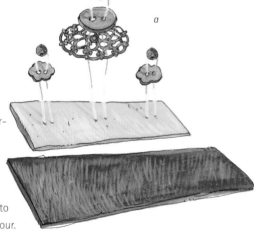

a

1 Cut 2 rectangles of pink felt of around 3 x 11 cm (1¼ x 4¼ ins). Stick the two layers together with fabric glue so they form a firmer base.

2 Cut a rectangle of green felt 2 x 9.5 cm (¾ x 3¾ ins).

3 Using nylon thread, sew on the central decoration. Go through the green felt rectangle from below and up through the stamping, the first hole in the button and the oval bead, then back through the second hole in the button, the stamping, and finally the felt. Repeat one more time, then make a double knot under the green felt rectangle (a).

4 To each side of the central motif, 1.5 cm (¾ in) from the edge of the green rectangle and working the same way as before, sew on the flower-shaped buttons with a filigree bead on top (a).

5 Using fabric glue, stick this decorated rectangle centrally on to the pink felt base. Leave to dry for 1 hour.

6 Using jewellery glue, stick the whole piece to the hairslide base (b). Leave to dry for 12 hours.

b

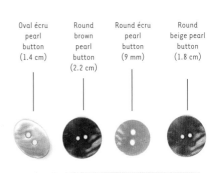

Oval écru pearl button (1.4 cm) Round brown pearl button (2.2 cm) Round écru pearl button (9 mm) Round beige pearl button (1.8 cm)

Pearly Teddy Bear

Teddy Bear Key-ring

Materials

Key-ring

Wool felt in chocolate brown

2 x 1.8 cm round beige pearl buttons

2 x 9 mm round écru buttons

1 x 2.2 cm round brown pearl button

1 x 1.4 cm oval écru pearl button

1 brass key-ring

Embroidery needle

Stranded embroidery cotton in chestnut brown

1 Cut 2 teddy bear heads of chocolate felt (see template, page 78) and cut a strip 1 x 4 cm (½ x 1½ ins).

2 Using 3 strands of embroidery thread, sew the buttons to one of the heads on the spots indicated on the template (page 78). Use the two big beige buttons for the ears and the two small écru buttons for the eyes. For the nose, place the oval button on top of the big brown button (a).

3 Put the two parts of the bear together and join them by blanket stitching round the edge with 3 strands of embroidery thread (see page 11), starting with one ear and working towards the bottom of the face. Stop when you reach the base of the second ear (b).

b

4 Fold the strip over the key-ring and insert it between the two ears. Continue blanket stitching, including the thickness of the strip. Blanket stitch the other side of the strip (c).

a

c

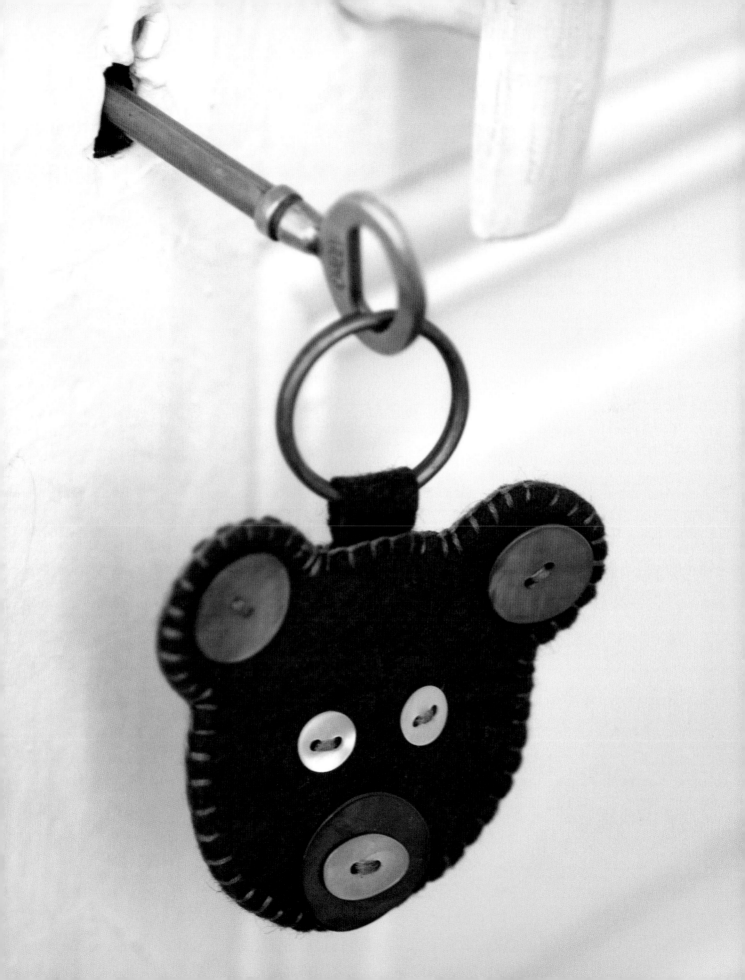

Flower-shaped beige pearl button (1.5 cm)

Round brown pearl button (2.2 cm)

Satin Fuxicos

M a t e r i a l s

Ring

Beige satin

1 x 1.5 cm flower-shaped beige pearl button

45 seed beads in old gold

Beige sewing thread

Nylon thread

Sewing needle and beading needle

Hairslide

Chocolate and beige satin

1 x 2.2 cm round brown pearl button

2 x 1.5 cm flower-shaped beige buttons

12 seed beads in old gold

1 x 8 cm long hairslide base

Matching sewing threads

Nylon thread

Sewing needle and beading needle

Ring

1 Cut a circle of satin 6 cm (2½ ins) in diameter and make a fuxico (see page 11) (a).

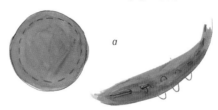

a

2 Thread the beading needle with 15 cm (6 ins) of nylon thread and pass the needle through the fuxico from underneath. Take the needle through one button hole, string 3 or 4 seed beads, go through the second hole and bring the needle out under the fuxico (b).

3 String about 20 beads on each strand. Cross the strands in a seed bead and make a very tight double knot. Cut off the ends and "weld" the knot in the heat of a flame.

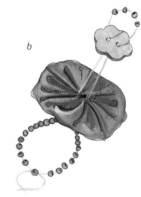

b

Hairslide

1 Cut circles of satin, 2 in beige, 6 cm (2½ ins) in diameter and 1 in chocolate, 12 cm (5 ins) in diameter, and make 3 fuxicos (see page 11).

2 Sew the buttons in the centre of each fuxico with nylon thread, stringing 3 or 4 seed beads (see step 2 of the ring). Make a very tight double knot underneath the fuxicos (a).

3 Using sewing thread, sew the two small fuxicos to either edge of the big one.

4 To finish, sew the decoration to the hairslide base (b).

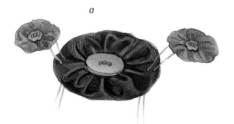

a

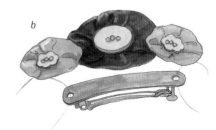

b

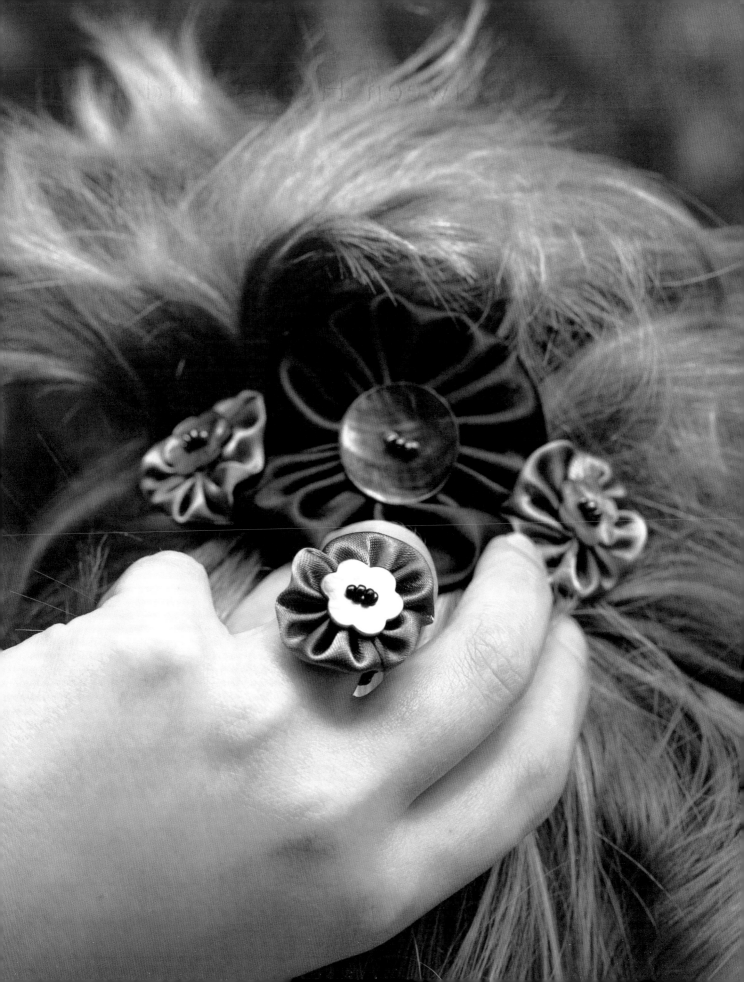

Between Heaven and Earth

Flower-shaped
lime green
pearl button
(2 and 1.2 cm)

Flower-shaped
turquoise
pearl button
(2 and 1.5 cm)

Belt

Materials

Belt

Olive green felt (or baize) 20 x 82 cm
(8 x 32½ ins). These dimensions are for a
hip measurement of 85-90 cm (34-36 ins).

Turquoise felt

Lime green flower-shaped pearl buttons:
4 x 2 cm and 3 x 1.2 cm

Turquoise flower-shaped pearl buttons:
1 x 2 cm and 4 x 1.5 cm

2 x 2.3 cm round brass filigree stampings

2 x 2.2 cm flower-shaped brass stampings

2 x 1.7 m (1¾ yds) lengths of 3 mm
satin ribbon, 1 in lime green and
1 in turquoise

Stranded embroidery thread in lime
green and turquoise

Tacking cotton

Embroidery needle and sewing needle

1 Trace off the belt template (see page 78) four times and join the pieces end to end to make the complete pattern for the belt. Cut two of the base of the belt in olive green felt. From the offcuts, cut 3 x 3.5 cm (1½ ins) circles. From the turquoise felt cut 3 x 5 cm (2 ins) circles, 2 x 3.5 cm (1½ ins) circles and 4 ogives (see template, page 78).

2 Sew a decorative border of blanket stitch around one olive green circle using 3 strands of turquoise embroidery thread (see page 11). Blanket stitch around all the other circles in olive green. Decorate the ogives with small olive green running stitches (see page 10) 2 mm (⅛ in) from the edge.

3 Find the centre of the ribbons and match it to the centre of one of the belt bases. Using tacking cotton, baste the two ribbons in place, side by side, along the middle of the belt.

4 Make the central decoration (see figure a, position 1). Place a 1.2 cm lime green button on a 2 cm turquoise button, then on the circle of olive green felt with the turquoise border, and finally on one of the 5 cm turquoise felt circles. Put them all together by sewing them in the centre of the belt with 6 strands of turquoise embroidery thread (go through the holes twice) (b). Make sure the stitches go through the ribbons.

b

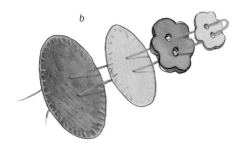

5 The following instructions apply to one side of the belt, starting at the centre and working outwards (a). Place a 1.2 cm lime green flower-shaped button on top of a flower-shaped stamping, then on a turquoise ogive (c). Sew this to the belt with 6 strands of lime green embroidery thread (see figure a, position 2).

c

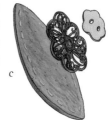

a

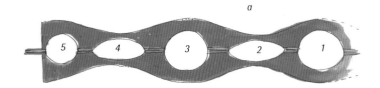

6 Place a 1.5 cm turquoise button on a 2 cm lime green button, then on a 5 cm circle of olive green felt, and finally on a 5 cm circle of turquoise felt. Sew this to the belt with 6 strands of lime green embroidery thread (d) (see figure a, position 3).

7 Next, place 1 round stamping on a turquoise felt ogive (e). Using 6 strands of lime green embroidery thread, sew them to the belt through the centre of the stamping with stitches radiating to form a star shape (see figure a, position 4).

8 Finish by placing a 1.5 cm turquoise button on a 2 cm lime green button, then on a 3.5 cm circle of turquoise felt (f). Sew this to the end of the belt (see figure a, position 5). For the second half of the belt, repeat steps 5 to 8 in the same sequence, starting from the middle.

e

d

f

9 Put the decorated belt base on top of the other one. Pin the two thicknesses together, adjusting them so you can sew them together with a border of blanket stitch in green (see page 11). Remove the tacking thread.

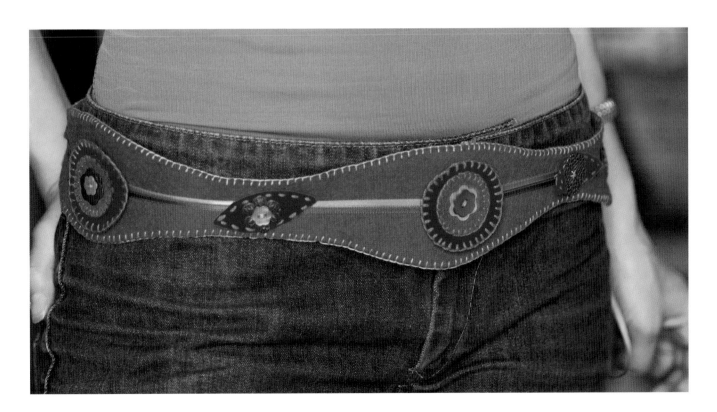

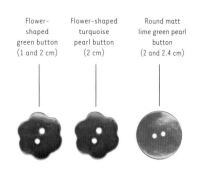

Flower-shaped green button (1 and 2 cm)

Flower-shaped turquoise pearl button (2 cm)

Round matt lime green pearl button (2 and 2.4 cm)

Materials

Ring

Turquoise felt

1 x 2.4 cm round matt lime green pearl button

1 x 2 cm turquoise flower-shaped pearl button

1 x 1 cm lime green flower-shaped pearl button

Stranded embroidery thread in lime green

Sewing thread or 3 strands of embroidery thread in turquoise

1 brass ring base with 1.5 cm diameter pad

Embroidery needle

Jewellery glue

Necklace

Turquoise felt

1 x 2.5 cm round brass filigree stamping

1 x 2 cm lime green flower-shaped pearl button

2 brass end caps

1 brass lobster-claw clasp

1 brass bail (or 2 x 5 mm jump rings)

Brass jump rings: 1 x 6 mm and 2 x 5 mm

Stranded embroidery thread in lime green

About 45 cm (18 ins) rat-tail cord

Embroidery needle

Ring

1. Cut a 3 cm (1¼ ins) circle of turquoise felt and embroider round the edge in blanket stitch, using 3 strands of lime green embroidery thread (see page 11).

2. Place the small lime green button on the flower-shaped turquoise button and then on the round lime green button. Match up the holes. Sew them to the circle of turquoise felt with turquoise thread (a).

3. Glue the decoration to the pad of the ring base (a). Leave to dry in a horizontal position for 12 hours (see page 8).

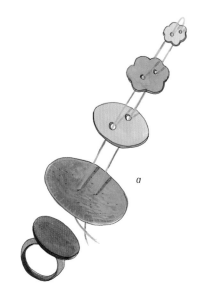

Necklace

1. Cut a 4 cm (1½ ins) circle of turquoise felt and embroider round the edge in blanket stitch, using 3 strands of lime green embroidery thread (see page 11), taking alternate large and small stitches.

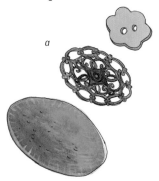

2. Place the flower-shaped button on the stamping and sew them to the centre of the felt circle using 6 strands of lime green embroidery thread (a). Pass the stem of the bail through the felt circle (see page 10), 5 mm (¼ in) from the edge (or you can replace the bail with 2 jump rings). Thread 1 jump ring through the ring of the bail.

3. Thread the cord through the jump ring (b) and adjust it to the desired length. Finish by attaching the end caps, the jump rings and the lobster-claw clasp (see page 9).

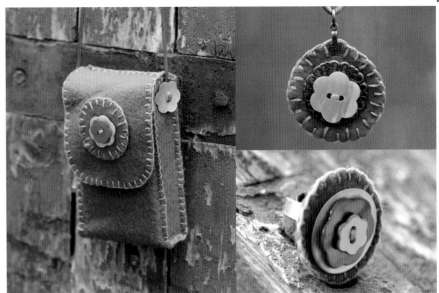

Materials

Mobile phone case

Olive green and turquoise felt

3 x 2 cm flower-shaped lime green pearl buttons

1 x 1.5 cm turquoise flower-shaped pearl button

Stranded embroidery thread in green and turquoise

About 70 cm (28 ins) rat-tail cord

2 x 1.5 cm round craft magnets

Embroidery needle and jewellery glue

Mobile Phone Case

1 From olive green felt, cut a rectangle 22.5 x 6.5 cm (9 x 2¾ ins) for the body of the case, another rectangle 9 x 6.5 cm (3½ x 2¾ ins) for the flap and 2 small strips 10 x 2.5 cm (4 x 1 in) for the sides of the case. Round off the bottom corners of the flap.

2 Lay the flap and the body of the case edge to edge. Stitch them together using blanket stitch and 3 strands of turquoise embroidery cotton (see page 11). Unfold them and embroider round the edge of the flap.

3 Make the case by blanket stitching the sides to the body of the case (a). Begin at the top of the side of the case at the back, and continue, folding the body so that 2.5 cm (1 in) of the edge is joined to the bottom edge of the side piece. Then work upwards, joining the other long edge of the side piece to the front of the case (b). Do the same with the other side of the case. Finish by blanket stitching the top edge of the case.

4 Thread one end of the cord through one hole in a green button from below. Go through the second hole from above and make a tight knot behind it. Do the same with the other end of the cord. Using 3 strands of embroidery cotton, sew the knot that is hidden behind the button to the top of the sides of the case, 1 cm (½ in) from the edge.

5 Decorating the flap: Cut a 3.5 cm (1½ in) circle of turquoise felt and embroider round the edge in blanket stitch, using 3 strands of green embroidery cotton and taking long and short stitches alternately. On the flap of the case, place the turquoise felt circle, the green button and the turquoise button one on top of the other (c) and sew them on, using 6 strands of green embroidery cotton.

6 Place your mobile phone in the case to give it the right shape. Join the magnets together in pairs so you can position the two parts accurately.

7 Glue one of the visible surfaces of each pair of magnets and stick it to the inside of the flap, under the decoration. Glue the other surface and gently close the flap over the front of the case, so the magnets stick to the felt in the right places. Press the whole case together gently and leave to dry overnight.

A String of Flowers

Turquoise pearl buttons of various shapes and sizes

Round natural pearl buttons of various sizes

Belt

Materials

Belt

15 x 140 cm (6 x 55 ins) felt (or baize) in chocolate

20 x 30 cm (8 x 12 ins) dark turquoise felt

20 x 30 cm (8 x 12 ins) light turquoise felt

Pearl buttons of various shapes and sizes in the same shades as the fabrics: 2 x 2.5 cm, 3 x 2 cm, 3 x 1.5 cm and 4 x 1.2 cm

Seed beads in old gold

1 large brass lobster-claw clasp

Brass rings: 10 x 2.5 cm diameter, 6 x 1 cm and 1 x 6 mm

Nylon thread

Stranded embroidery thread in turquoise

Embroidery scissors

Embroidery needle and beading needle

Flat nose pliers

1 Using embroidery scissors, cut 12 flowers in chocolate felt (see template 1, page 79). Cut 6 flowers in dark turquoise (see template 2, page 79), 6 in light turquoise (see template 3, page 79), 6 stars in light turquoise (see template 4, page 79), 6 chocolate stars (see template 5, page 79) and 12 strips 1 x 4 cm (½ x 1½ ins) in chocolate.

2 Lay one of each shape on top of one another in the same order you cut them out. Join them together by attaching the buttons of your choice with nylon thread. Sew through all 5 thicknesses. Go through one hole of the button or buttons, string 3 to 5 seed beads, depending on the size of the topmost button, and go down through the other hole or holes. Make a very tight knot at the back (a). Repeat five more times.

3 Place each motif on one of the six remaining chocolate flowers. Join the chocolate flowers and rings. Fold a small rectangle of felt in half over a brass ring, insert the two ends 1 cm (½ in) between the two layers of the flower (b). With 3 strands of turquoise thread, blanket stitch around the edge (see page 11). Start level with one of the loops, and stitch through its upper layer. With another needle and thread, blanket stitch the back of the loops in the same way. Continue to the start of the opposite petal. Slip another strip folded in two over a ring and embroider around the edge as before. Embroider round the other half of the edge of the flower. Continue until you have linked the sixth flower and the seventh ring.

4 Use the 6 mm ring to attach the lobster-claw clasp to the first ring of the belt (c). Join the remaining 3 rings to the last ring of the belt (see page 9), using the 6 x 1 cm rings (2 for each link) (d).

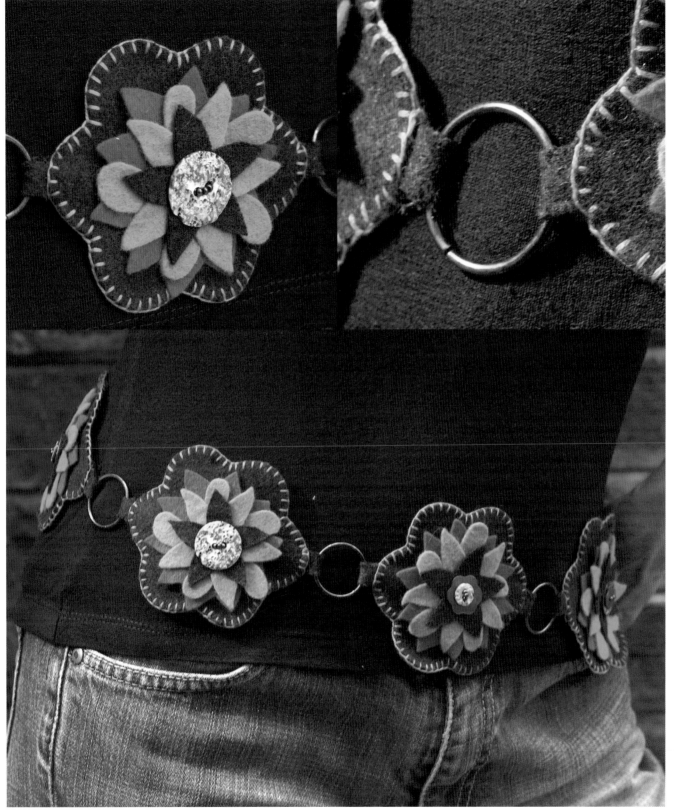

Round pearl
button
(1.8 cm)

Mobile Phone Case

 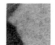

Materials

Mobile Phone Case

Chocolate, dark turquoise and light turquoise felt

1 x 1.8 cm round pearl button

4 seed beads in old gold

1 x 2.5 cm brass end clamp

1 large brass lobster-claw clasp

1 x 1 cm brass ring

Embroidery needle and beading needle

Nylon thread

Stranded embroidery thread in light turquoise

2 x 1.5 cm round craft magnets

Jewellery glue

Embroidery scissors

Flat nose pliers

1 Follow steps 1 to 3 of the mobile phone case "Between Heaven and Earth" (see page 47).

2 Cut flower 1 in chocolate felt (see template 1, page 79), flower 2 in dark turquoise felt (see template 2, page 79), and stars 3 and 4 in light turquoise felt (see templates 3 and 4, page 79). Lay them on top of one another in the same order. Thread a beading needle with 15 cm (6 ins) nylon thread, place the button in the centre of the flower, and sew together, passing through the felt from below and then through one of the holes in the button. String the beads, go through the second hole in the button, back through the flower, and make a tight knot at the back. Attach the decoration to the flap of the case with nylon thread (a).

3 Attach the end clamp centrally over the line of blanket stitch along the top of the case. Attach the ring to it (see page 9) and then the lobster-claw clasp.

4 Finish by following steps 6 and 7 of the phone case "Between Heaven and Earth" (see page 47).

a

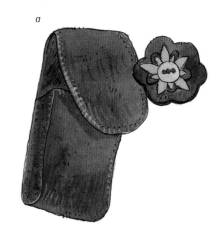

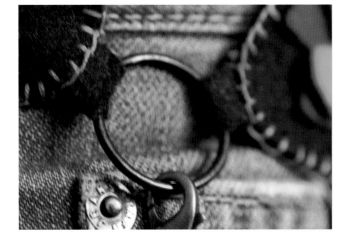

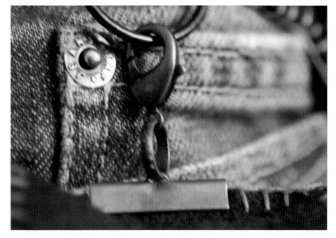

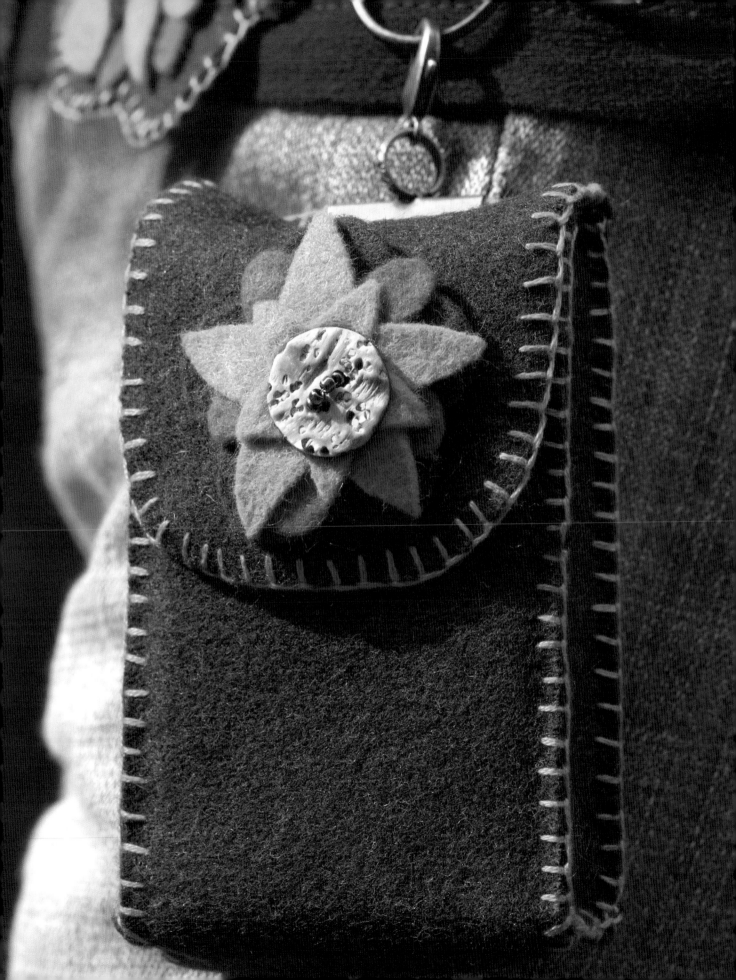

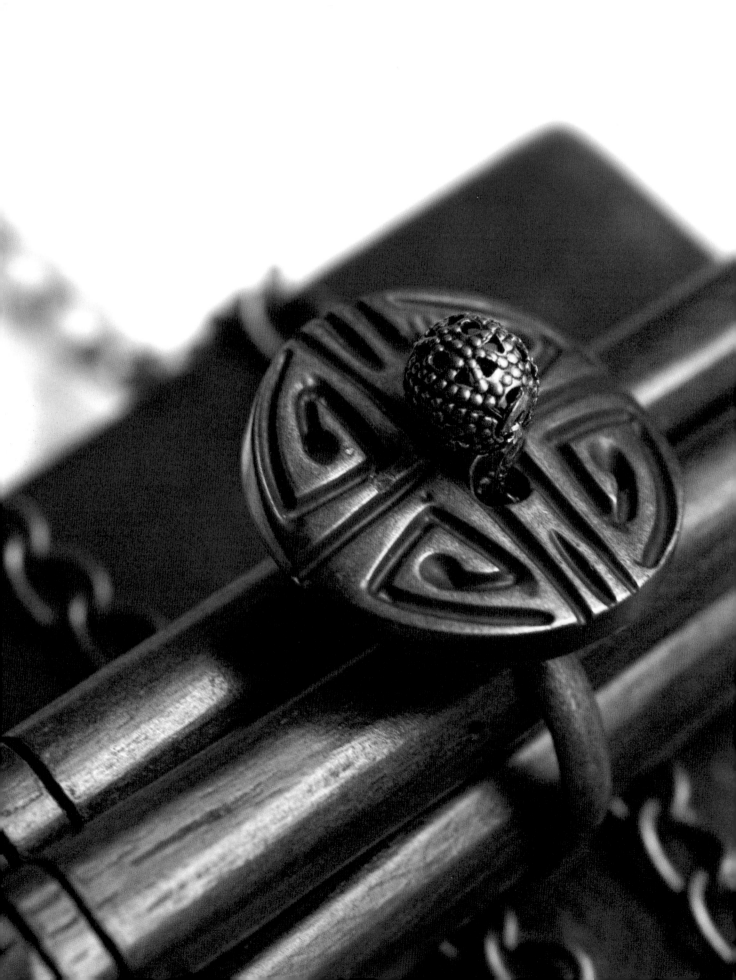

Back to our Buttons

Whether they are on an old, forgotten
garment, hidden in grandmother's
workbox, for sale on a marketstall or in
your favourite haberdashery store, look for
buttons that will turn your jewellery into a
unique design. From ethnically inspired
jewels with a glint of copper to those
containing all the colours of the artist's
palette, let your imagination run riot.

Geometric Buttons

Square designer button with 4 holes (1.8 and 2.5 cm)

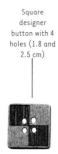

Square designer button with 4 holes (1.8 and 2.5 cm)

Materials

Necklace

Square designer button with 4 holes:
1 x 1.8 cm and 1 x 2.5 cm

55 cm (22 ins) x 3 mm flat imitation suede bootlace in chocolate

2 copper-coloured calottes

1 copper-coloured lobster-claw clasp

2 x 5 mm copper-coloured jump rings

Needle with large eye

Jewellery glue

Flat nose pliers

Ring

1 x 1.8 cm square designer button with 4 holes

10 cm (4 ins) x 3 mm flat imitation suede bootlace in chocolate

1 copper-coloured ring base with 1 cm diameter pad

Needle with large eye

Jewellery glue

Necklace

1 Cut the bootlace in two and thread the first piece through the needle. Go up through one hole in the 2.5 cm button from below, then back down through the second hole. Do the same with the 1.8 cm button. Slide the buttons along so they are 3 mm (⅛ in) apart, leaving an end about 4 cm (1½ ins) long after the 1.8 cm button.

2 Thread the second piece through the other row of holes in the same way and slide the buttons the same distance along. The buttons must be in a straight line with the laces (a).

3 Adjust the length of the necklace. Make a knot at the end of each of the long ends of the laces. Attach the calottes, the jump rings and the lobster-claw clasp (see page 9) (b).

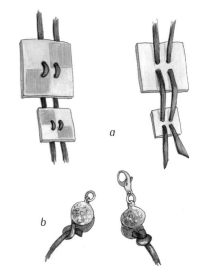

4 Cut the two short ends of the laces at an angle. Lay the necklace flat and turn it over. Fix the laces to the back of the buttons with a spot of glue. Leave to dry for 2 hours.

Ring

1 Use the large-eyed needle to thread the bootlace up through one hole in the button, down through a second hole, then back up through the third hole next to it (make sure the lace does not twist). Go down through the fourth hole (a).

2 Cut the laces off underneath the button, 3 mm (⅛ in) from the holes. Glue the ends nice and flat to the back of the button. Leave to dry for 1 hour.

3 Glue the button to the pad of the ring base and leave to dry overnight in a horizontal position (see page 8).

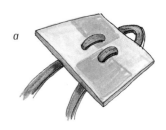

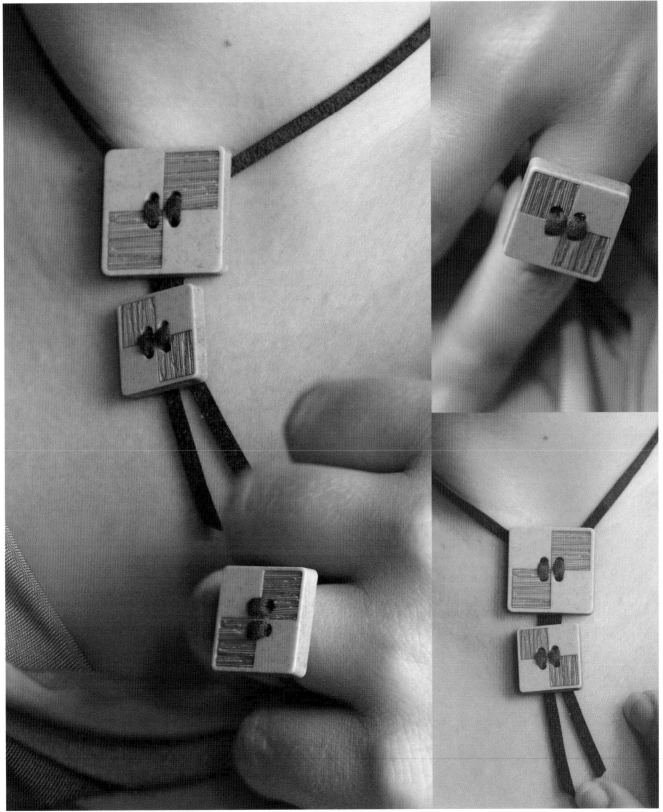

Ethnically Inspired

Indian button
(3 and 2.5 cm)

Materials

Earrings

2 x 2.5 cm Indian buttons

2 x 8 mm brass eyelet pads

French clips with shell motif in brass

Jewellery glue

Flat nose pliers

Brooch

1 x 3 cm Indian button that has a ring for sewing on

5 different brass dangles

8 cm (3¹/₄ ins) brass chain with large links

8 x 3 mm brass jump rings

1 brass safety-pin brooch with 5 rings

Flat nose pliers

Earrings

1 Glue an eyelet pad to the back of each button, with the eyelet protruding beyond the edge of the button. Leave to dry overnight in a horizontal position (a).

a

2 Open the ring of the French clip (see page 10), insert the ring of the pad and close again (b).

b

Brooch

1 Slip a jump ring through the ring on the button and attach it to the central ring of the safety-pin brooch (see page 9) (a).

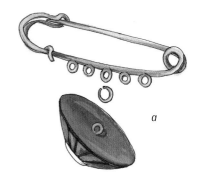

a

2 Slip another jump ring through the first link of the chain and attach it to the first ring of the brooch. Attach the last link to the last ring of the brooch in the same way.

3 To finish, use jump rings to attach the five dangles to the chain, spacing them out evenly (b).

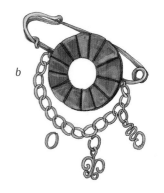

b

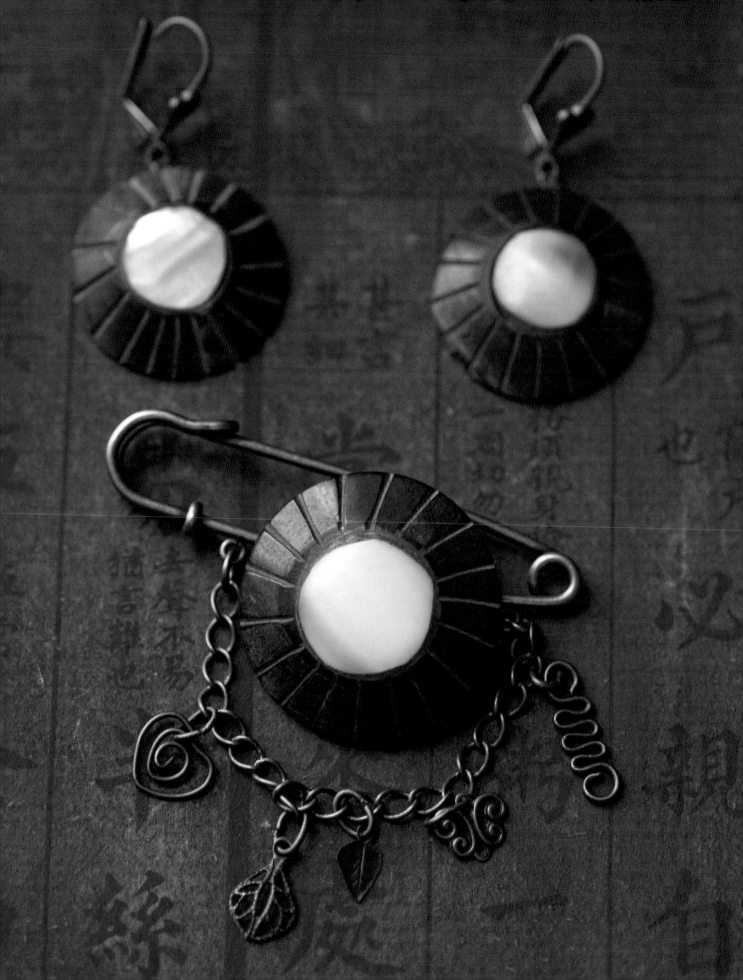

Fancy
button
(2.5, 2 and
1.5 cm)

Aztec Treasures

Earrings

Materials

Earrings

4 x 1.5 cm round fancy buttons

2 x 6 mm filigree brass beads

Brass jump rings: 8 x 8 mm and 4 x 4 mm

1 brass eye pin

French clips with shell motif in brass

Round nose pliers, flat nose pliers and wire cutters

Ring

1 x 1.5 cm round fancy button

1 x 6 mm filigree brass bead

1 brass ring base 1 cm diameter pad

Nylon thread

Jewellery glue

1 Attach 2 x 8 mm jump rings to each button (see page 9). Link them together in pairs with a 4 mm jump ring.

2 Make a dangle (see page 10). String a filigree bead on the eye pin. Cut the pin off 6 mm (¼ in) above it. With flat nose pliers fold over the end and squeeze it. Use the rest of the pin for the second dangle. Make a loop at one end (see page 10), string the second bead, cut the pin off 6 mm from the bead and finish as the first one (a).

3 Attach a dangle to the bottom ring of each of the earring drops. Attach the other end of the drops to the French clips with 4 mm jump rings (b).

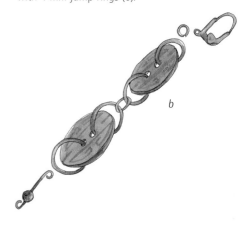

b

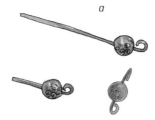

a

Ring

1 Using nylon thread, sew the bead to the button (a), passing the thread through three times. Make a tight double knot at the back of the button by one of the holes.

2 Glue the button to the pad of the ring base (b). Leave to dry overnight in a horizontal position (see page 8).

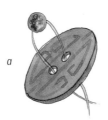

a

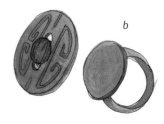

b

Necklace

Materials

Necklace

Fancy buttons: 1 x 2.5 cm, 1 x 2 cm and 1 x 1.5 cm

Filigree brass beads: 1 x 3 mm and 1 x 6 mm

About 38 cm (15 ins) brass chain with large links

1 brass eye pin

5 brass eyelet pads

1 brass lobster-claw clasp

Brass jump rings: 1 x 8 mm, 2 x 6 mm and 2 x 4 mm

Round nose pliers, flat nose pliers and wire cutters

Jewellery glue

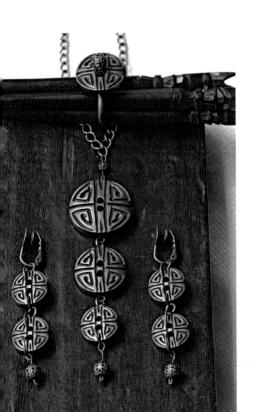

1 Glue 2 eyelet pads to the back of the 2.5 cm button. Do the same with the 2 cm button. Glue the remaining eyelet pad to the back of the 1.5 cm button (a). Take care to align the eyelets with the holes in the buttons. Leave to dry for 1 hour.

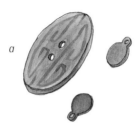

2 Insert an 8 mm jump ring into the lower hole in the 1.5 cm button (b).

3 Make the bead dangles (see page 10). String a 3 mm brass bead on the eye pin and cut off the pin 1 cm (½ in) above the bead. Make a loop using the round nose pliers. Use the rest of the eye pin to make a second dangle. Using the flat nose pliers, fold down the end and squeeze. String the 6 mm bead and make a loop with the round nose pliers.

4 Link the 2.5 cm and 2 cm buttons by inserting a 4 mm jump ring through one eyelet on each button. Link the eyelet on the 1.5 cm button to the second eyelet on the 2 cm button with another 4 mm jump ring (c).

5 Hang the dangle with the 6 mm bead from the 8 mm jump ring in the 1.5 cm button. Attach the other dangle to the remaining eyelet on the 2.5 cm button (c).

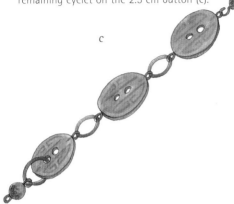

6 Lay the chain flat. Find the centre link and attach the pendant of buttons by opening and re-closing the upper loop of the dangle (d).

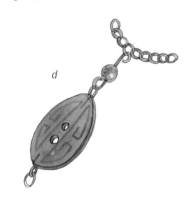

7 To finish, attach a 6 mm jump ring to each end of the chain and attach the clasp (see page 9) (e).

Glints of Copper

Ring

Fancy button
(1 and 2 cm)

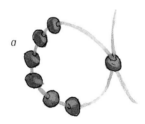

Materials

Ring

1 x 2 cm round fancy button

Seed beads in old gold

Copper wire

Earrings

4 x 1 cm round fancy buttons

8 cm (3¼ ins) fine copper chain (note: the links of the chain must be big enough to take the jump rings)

8 x 5 mm copper jump rings

Earring wires

Flat nose pliers and wire cutters

Bracelet

6 x 1 cm round fancy buttons

15 to 18 cm (6 to 7 ins) copper chain

8 x 5 mm copper jump rings

1 copper ball clasp

Flat nose pliers

1 String 7 seed beads in the middle of 50 cm (20 ins) copper wire. Make a loop by crossing the strands in the seventh bead (a).

a

2 Thread both strands together through one hole in the button, with the loop of beads underneath the button. String 4 seed beads and thread both strands back through the second hole in the button (b).

b

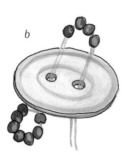

3 To begin the ring, string 3 seed beads on each strand, then cross the strands in 3 more beads. For the following rows, simply cross the strands in 3 more beads. Pull both strands to keep the work tight. Make as many rows as needed for the size you want (c).

c

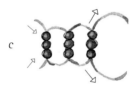

4 Close the ring by threading each strand through 3 beads in the loop you made at the start. Twist the strands together and, if possible, feed them through another bead in the ring. Cut the ends off level with the beads.

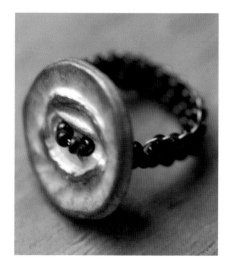

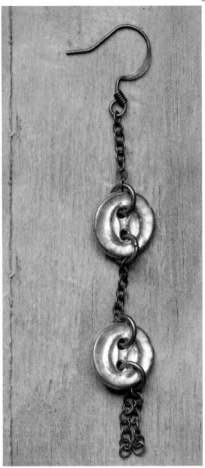

Earrings

1 Using the wire cutters, prepare 8 pieces of chain about 1 cm (½ in) long. Attach the first link of a piece of chain to the ring of each earring wire (see page 10) (a).

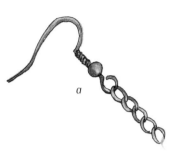

a

2 Using the flat nose pliers, open a jump ring (see page 9) and slip it into the last link, then through the hole of a button. Close the jump ring. Insert another jump ring into the other hole in the button. Slip the same jump ring into the end of another piece of chain and close it (b).

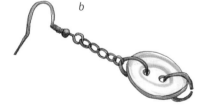

b

3 Attach the second button in the same way as the first, and attach two pieces of chain to the last jump ring (c).

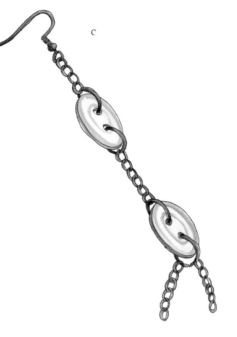

c

Bracelet

1 Lay the chain out flat in front of you. Open a jump ring (see page 9), slip it through a hole in a button and attach it to one link of the chain. Close the jump ring. Attach the remaining five buttons in the same way, spacing them about 1.5 cm (¾ in) apart. Finish by attaching the clasp (see page 9). Attach each part to the chain with 1 jump ring.

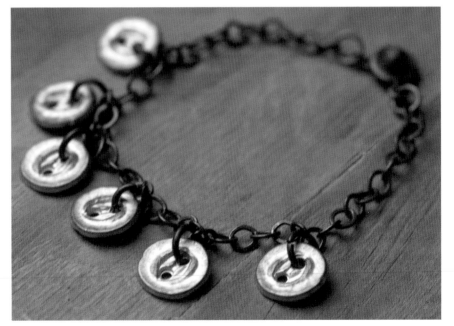

Round taupe fancy button (2.5 cm)

Round pink fancy button (2.5 cm)

Classic Curves

Ring

Materials

Ring

1 x 2.5 cm round pink fancy button

1 x 1.4 cm brass flower

1 brass ring base with 1 cm diameter pad

Jewellery glue

Necklace

2.5 cm round fancy buttons with 4 holes: 5 in pink and 3 in taupe

1 brass lobster-claw clasp

2 x 5 mm brass jump rings

120 cm (48 ins) of taupe cotton cord

Flat nose pliers

1 Glue the brass flower to the centre of the button. Glue the whole motif to the pad of the ring base. Leave to dry overnight in a horizontal position (see page 8) (a).

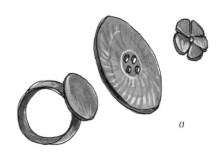

a

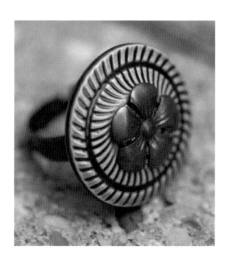

Necklace

1 Thread the two ends of the cord up through two holes in a pink button from below so the button is in the centre of the cord. Thread the ends down through the other two holes from above (a).

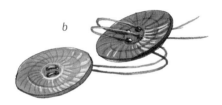

a

2 String a taupe button in the same way (b).

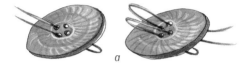

b

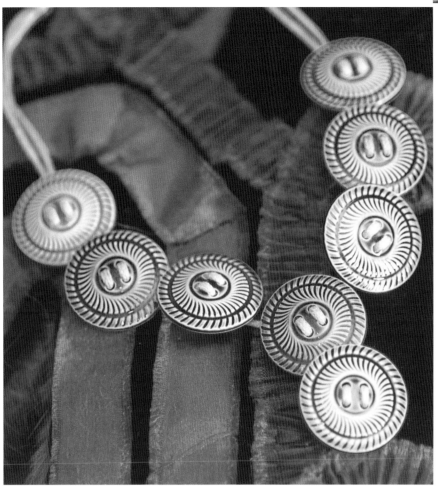

3 Make one side of the necklace first, then the other. Thread the right-hand strand through the right-hand holes in a pink button, then a taupe button and a final pink button (c).

4 Leaving a sufficient length of cord, go back the opposite way, through the left-hand holes of the last three buttons (pink, taupe, pink). Try on the "half-necklace" (the fold in the cord should reach the middle of the back of your neck). Then make a knot under the pink button. Complete the left side of the necklace to match (c).

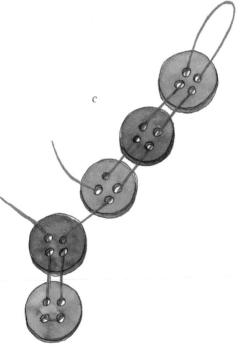

c

5 To finish, make a knot in each end of the cord, forming a loop as you do so. Insert the jump rings and attach the lobster-claw clasp (see page 9) (d).

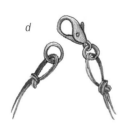

d

Round orange fancy button (9 mm)

Round violet fancy button (9 mm)

Round turquoise fancy button (9 mm)

Materials

Earrings

9 mm round fancy buttons with rings at the side for attaching: 2 in orange and 2 in violet

2 x 3 mm silver-coloured jump rings

Earring mounts with silver-coloured posts and flat pads

Flat nose pliers

Jewellery glue

Ring

9 mm round fancy buttons with rings at the side for attaching: 2 in turquoise, 1 in orange and 1 in violet

4 x 3 mm silver-coloured jump rings

1 silver-coloured ring base with rings for attaching on top

Flat nose pliers

Bracelet

9 mm round fancy buttons with rings at the side for attaching: 3 in turquoise, 3 in orange and 3 in violet

11 x 3 mm silver-coloured jump rings

15 to 18 cm (6 to 7 ins) silver-coloured chain with large links

1 silver-coloured lobster-claw clasp

Artist's Palette

Earrings

1 Join the pairs of buttons (1 orange and 1 violet) together by inserting a 3 mm jump ring through the rings on the buttons (see page 9) (a).

2 Glue the orange buttons to the pads of the earring mounts. Leave to dry overnight in a horizontal position (see page 8) (b).

Ring

1 Open the jump rings with the flat nose pliers (see page 9). Insert them into the rings on the buttons and join them to the rings on the ring base (a).

Bracelet

1 Attach the buttons to the links of the chain with jump rings, spacing them about 1.5 cm (¾ in) apart (a).

2 To finish, attach a jump ring to each end of the chain and attach the clasp (see page 9) (b).

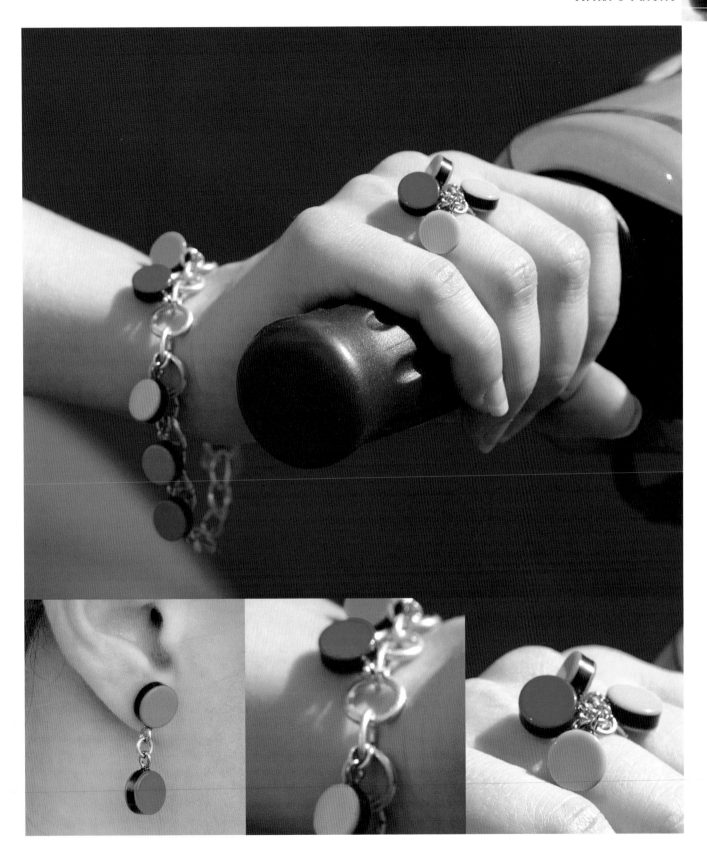

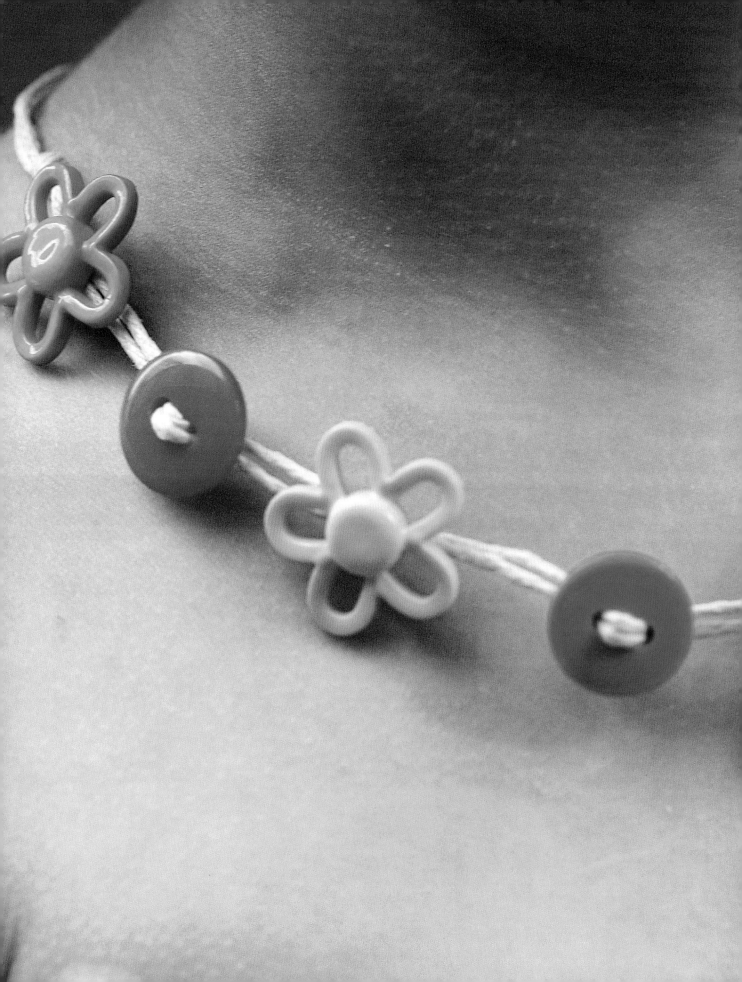

Just like Mum

Amusing and colourful
jewellery for little girls who
want to be as pretty as their
mothers. Pearly hearts, button
flowers, mint and aniseed
pastilles – irresistible jewellery.
Mums will love them too!

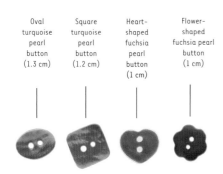

Oval turquoise pearl button (1.3 cm)	Square turquoise pearl button (1.2 cm)	Heart-shaped fuchsia pearl button (1 cm)	Flower-shaped fuchsia pearl button (1 cm)

Pearly Hearts

Bracelet

Materials

Bracelet

4 x 1 cm heart-shaped pearl buttons in fuchsia

3 x 1.3 cm long oval pearl buttons in turquoise

1 silver-coloured lobster-claw clasp

Silver-coloured jump rings: 17 x 6 mm and 6 x 4 mm

Flat nose pliers

Ring

1 x 1.2 cm square pearl button in turquoise

1 x 1 cm flower-shaped pearl button in fuchsia

1 x 4 mm turquoise bicone

About 30 seed beads in fuchsia

Stretchy nylon thread

Flat nose pliers

1 Using the flat nose pliers, insert a 6 mm jump ring in each hole in the buttons (see page 9) (a).

a

2 Link the buttons together with a 4 mm jump ring, to form a small chain (b).

b

3 Attach a 6 mm jump ring to one end of the chain and attach the lobster-claw clasp to the ring. At the other end, attach 2 x 6 mm jump rings (or more, depending on the size of the wrist) (c).

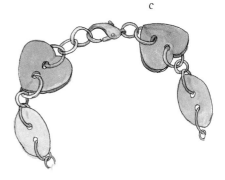

c

Ring

1 Place the flower-shaped button on the square button and match up the holes.

2 Cut 15 cm (6 ins) stretchy nylon thread. Go up through the holes from below, string the turquoise bicone and go down through the other holes (a).

a

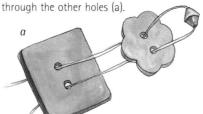

3 String 30 seed beads on one of the strands. Make a firm double knot. Feed each strand back through 3 or 4 beads (on each side of the ring) (b).

b

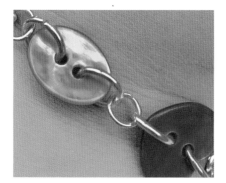

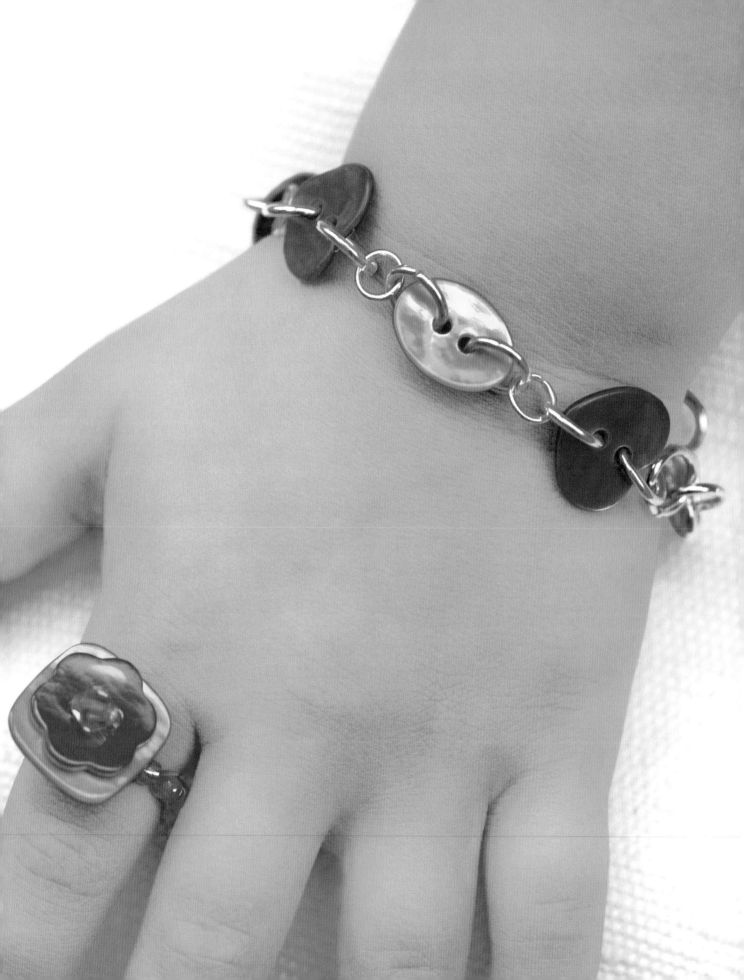

Round lime green fancy button with 4 holes (1.2 cm)

Round turquoise fancy button with 4 holes (1.2 cm)

Mint and Aniseed Pastilles

Materials

Bracelet

Round 1.2 cm fancy buttons with 4 holes: 4 in turquoise and 3 in lime green

2 silver-coloured calottes

1 silver-coloured lobster-claw clasp

2 x 3 mm silver-coloured jump rings

30 cm (12 ins) fine turquoise leather cord

Flat nose pliers

Jewellery glue

Ring

1 round 1.2 cm fancy button with 4 holes in turquoise

About 30 lime green seed beads

Beading needle with flexible eye

Stretchy nylon thread

Bracelet

1 Cut the cord in two. Thread the first piece through the right-hand holes in the buttons and the second piece through the left-hand holes (see page 9). Alternate the two colours and leave a space of about 5 mm (¼ in) between the buttons (a).

2 Adjust the length of the bracelet, then knot the two strands together at both ends (b).

3 To finish, put a spot of glue in the calottes and close them over the knots with the flat nose pliers. Attach the jump rings and the lobster-claw clasp (see page 9) (b).

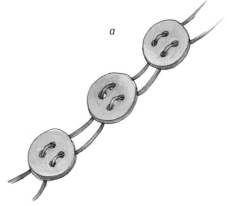

a

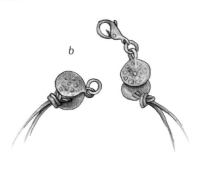

b

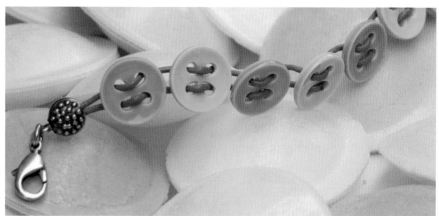

Ring

1 Pass the thread through one of the holes in the button, string 3 seed beads, then go through the second, opposite hole. Bring the thread out underneath the button (a).

2 Then take the thread through the third hole (diagonally opposite the second). String 3 seed beads and take the thread down through the fourth hole (b).

3 To make the ring, string 30 seed beads on one of the strands, and make a very tight double knot with the other strand. Thread each strand through 3 or 4 beads, then cut off the ends (c).

a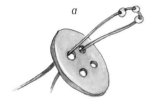

b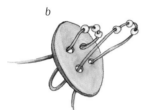

c

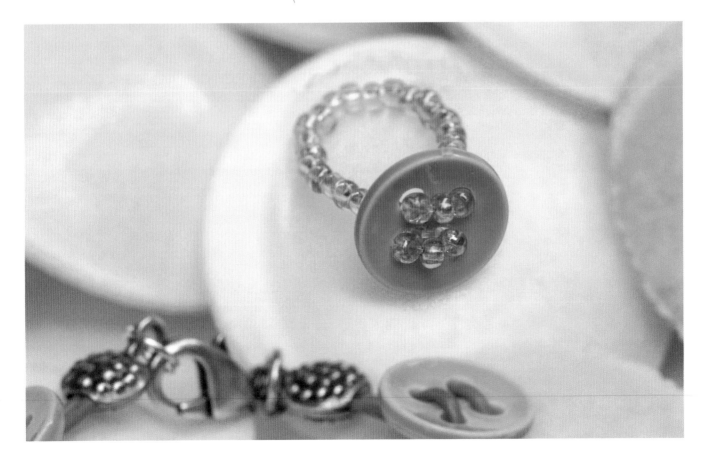

A Walk in the Garden

Green handbag-shaped fancy button (1.5 cm)

Fuchsia flower-shaped fancy button (1.2 cm)

Hairslide

Materials

Hairslide

Fuchsia felt

Lime green felt

3 x 1.2 cm flower-shaped fancy buttons in fuchsia with ring for attaching

1 x 6 cm long hairslide

Fuchsia sewing thread

Sewing needle

Fabric glue

Jewellery glue

Bracelet

3 x 1.2 cm flower-shaped fancy buttons in fuchsia with ring for attaching

4 x 1.5 cm handbag-shaped fancy buttons in green with ring for attaching

1 silver-coloured lobster-claw clasp

Silver-coloured jump rings: 1 x 6 mm and 1 x 4 mm

2 silver-coloured end caps

13 to 15 cm (5 to 6 ins) x 3 mm flat imitation suede bootlace in lime green, depending on the size of the wrist

Needle with large eye

Jewellery glue

Flat nose pliers

1 Cut 2 rectangles, 8 x 2.5 cm (3¼ x 1 in), of fuchsia felt. Cut a third rectangle the same size plus 3 x 2 cm (¾ in) diameter circles of lime green felt.

2 Arrange the 3 circles in a row along the centre of one of the fuchsia rectangles. Sew one flower-shaped button on each circle (a).

3 Making sure you centre it carefully, stick the second fuchsia rectangle to the hairslide with jewellery glue. Using fabric glue, stick the green rectangle to the fuchsia rectangle and finally the decorated fuchsia rectangle on top of that. Leave to dry overnight.

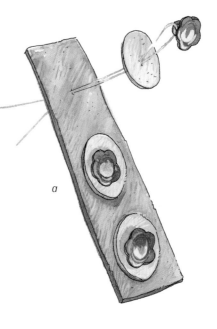

a

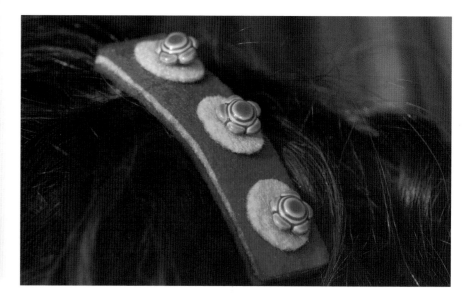

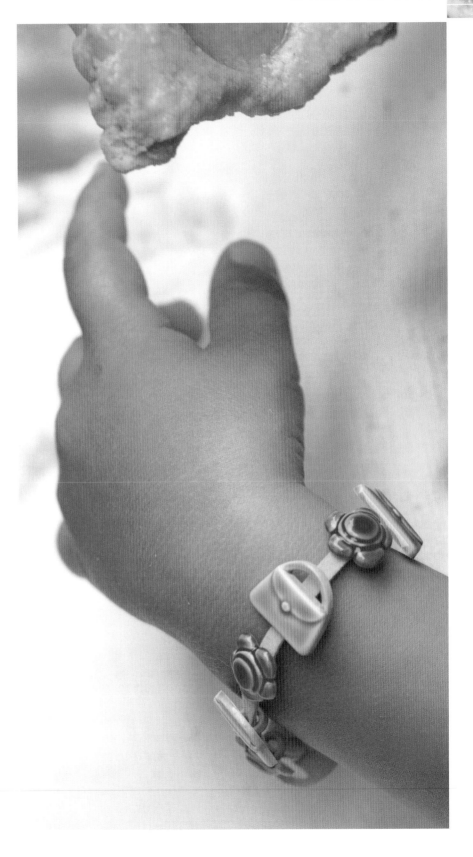

Bracelet

1 Thread the bootlace through the large-eyed needle. Thread it through the rings on the buttons, taking care the lace does not twist. Start with a handbag button, then a flower, and so on. Space them evenly along the lace (a).

2 Adjust the length of the bracelet, then attach 1 end cap to each end of the lace (see page 9). Attach the 6 mm jump ring to one end cap and attach the clasp to the other end using the 4 mm jump ring (see page 9) (a).

3 Turn the bracelet over and lay it flat. Fix the lace to each button with a spot of glue. Leave to dry overnight.

a

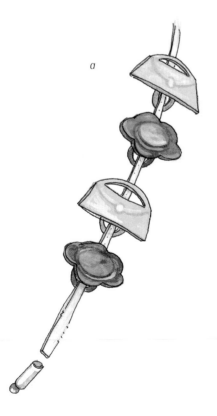

73

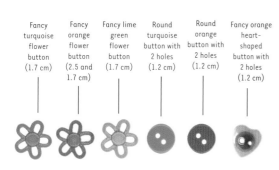

Fancy turquoise flower button (1.7 cm) | Fancy orange flower button (2.5 and 1.7 cm) | Fancy lime green flower button (1.7 cm) | Round turquoise button with 2 holes (1.2 cm) | Round orange button with 2 holes (1.2 cm) | Fancy orange heart-shaped button with 2 holes (1.2 cm)

Button Flowers

Necklace

Materials

Necklace

1 x 2.5 cm fancy flower-shaped button with ring for attaching in orange

1.7 cm fancy flower-shaped buttons with ring for attaching: 2 in turquoise and 2 in lime green

1.2 cm round 2-hole buttons: 2 in orange and 2 in turquoise

1 silver-coloured lobster-claw clasp

2 x 6 mm silver-coloured jump rings

2 silver-coloured end caps

About 70 cm (28 ins) cotton cord in lime green

Flat nose pliers

Jewellery glue

Scrunchy

1 orange scrunchy

1 x 2.5 cm fancy flower-shaped button with ring for attaching in orange

1.7 cm fancy flower-shaped buttons with ring for attaching: 2 in lime green and 2 in turquoise

5 x 1.2 cm two-tone heart-shaped buttons (orange and green)

Stranded embroidery cotton in lime green

Embroidery needle

1 Cut the cord into 2 equal pieces. String the orange flower-shaped button on both cords. Position it in the middle and fix it by knotting the double cord around the ring on the back of the button (a).

2 On either side of this first button and at an equal distance from it, string 1 round turquoise button. Continue, keeping the two sides symmetrical, by stringing 1 lime green flower button, then 1 round orange button and finally 1 turquoise flower. With each flower button, knot the cords to the ring on the back (b).

a

b

3 Finish by making a knot in each end, 1 cm (½ in) from the final buttons. Attach the end caps, the jump rings and the lobster-claw clasp (see page 9).

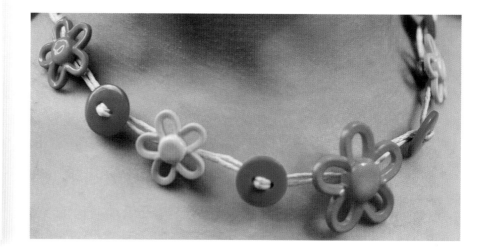

Scrunchy

1 Stretch the scrunchy around a carton or some other rigid object.

2 Thread the needle with 3 strands of lime green embroidery cotton. Pass the needle in from underneath the scrunchy and come out on top. Go through the ring of the large orange button and sew it to the scrunchy, only going through the top layer.

3 Bring the needle out. Sew a running stitch (see page 10), then sew on the buttons (spacing them evenly and separating them by a running stitch) in the following order: 1 heart-shaped button, 1 turquoise flower, 1 heart, 1 lime green flower, and so on.

4 Finish off the last stitch underneath the scrunchy and make a knot.

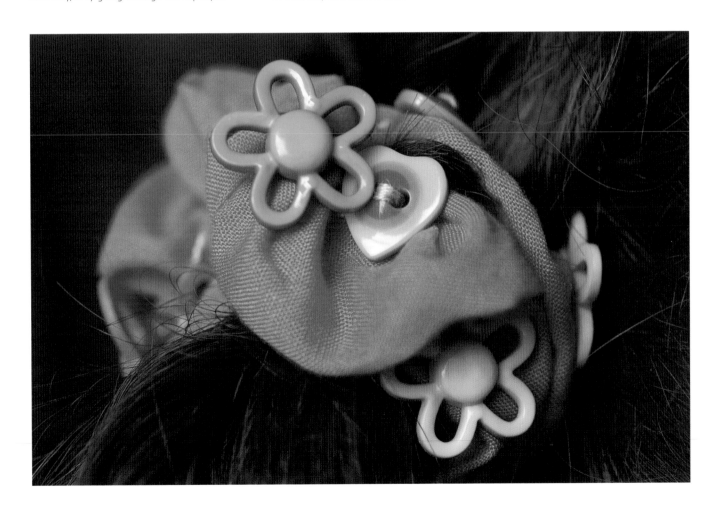

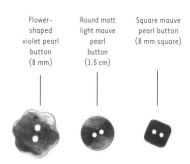

Flower-shaped violet pearl button (8 mm)

Round matt light mauve pearl button (1.5 cm)

Square mauve pearl button (8 mm square)

Materials

Ring

1 x 1.5 cm round pearl button in matt light mauve

1 x 8 mm square pearl button in mauve

3 silver-coloured seed beads

1 child-sized silver-coloured ring base with flat pad

Nylon thread

Jewellery glue

Necklace

1 x 2.5 cm flower-shaped pearl sequin in violet

1 x 8 mm flat, flower-shaped, silver-coloured charm

2 silver-coloured end caps

1 silver-coloured lobster-claw clasp

3 x 5 mm silver-coloured jump rings

40 cm (16 ins) waxed cotton cord in violet

Flat nose pliers

Jewellery glue

Violet Jewels

Ring

1 Place the square button on the round button, matching the holes.

2 Pass the nylon thread up through the holes in the buttons from below, string the beads, then pass the thread down through the other holes (a).

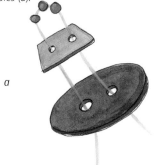

a

3 Make a very tight double knot under the buttons and slide it into the hole of one of the buttons.

4 Glue the pad of the ring base, place the button motif on it and press firmly (b). Leave to dry for 12 hours in a horizontal position (see page 8).

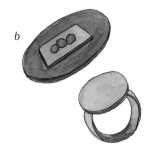

b

Necklace

1 Using the flat nose pliers, open a jump ring (see page 9) and slide it through the sequin hole and the ring of the charm. Close up the ring (a).

a

2 Thread the cord through the jump ring, make a knot at each end, then attach the end caps and the clasp (see page 9) (b).

b

Materials

Bracelet

3 x 8 mm flower-shaped pearl buttons in violet

2 x 1.5 cm round pearl buttons in matt mauve

2-3 cm ($^3/_4$ to $1^1/_4$ ins) silver-coloured chain (or make one using 3 x 5 mm jump rings, see page 10)

2 silver-coloured calottes

1 silver-coloured lobster-claw clasp

2 x 5 mm silver-coloured jump rings

20 cm (8 ins) waxed cotton cord in violet

Flat nose pliers

Jewellery glue

Bracelet

1 String 1 flower-shaped button 5 cm (2 ins) from one end of the cord (see page 9). Continue with 1 round button, 1 flower button, 1 round button, then the last flower button (a).

2 Make a finishing knot at each end, about 3 cm (1¼ ins) from the flower buttons. Cut the ends off level with the knots.

3 Attach the calottes. Using jump rings, attach them to the clasp (see page 9) and the chain (b). Adjust the length of the chain to the size of the wrist.

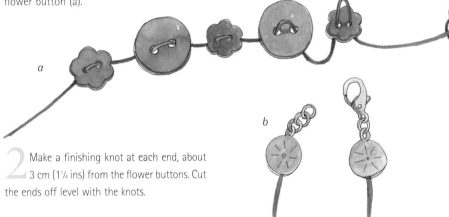

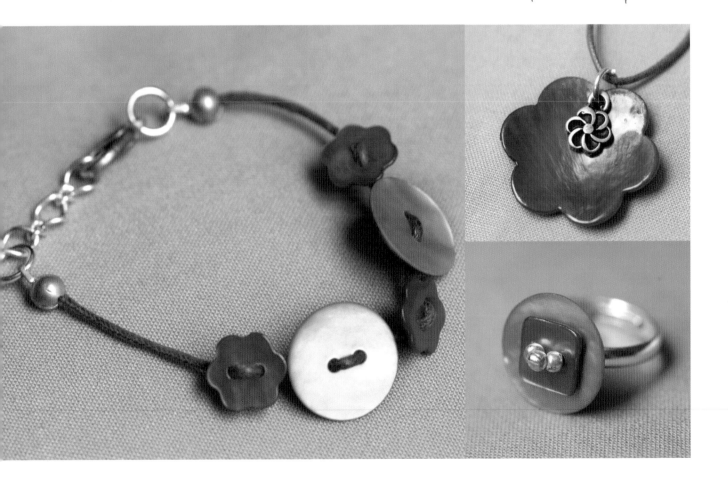

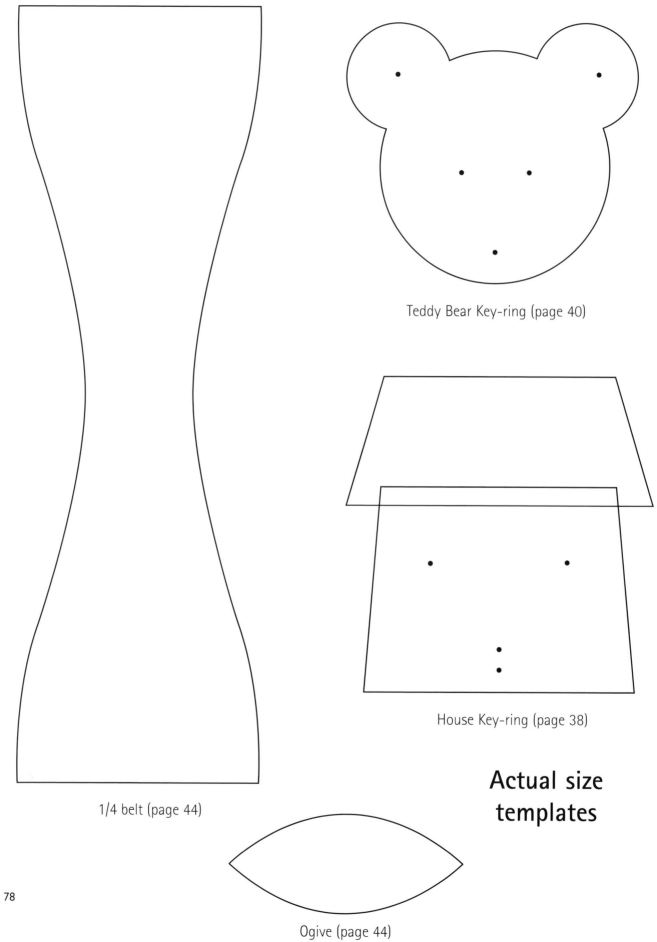

Teddy Bear Key-ring (page 40)

House Key-ring (page 38)

Actual size templates

1/4 belt (page 44)

Ogive (page 44)

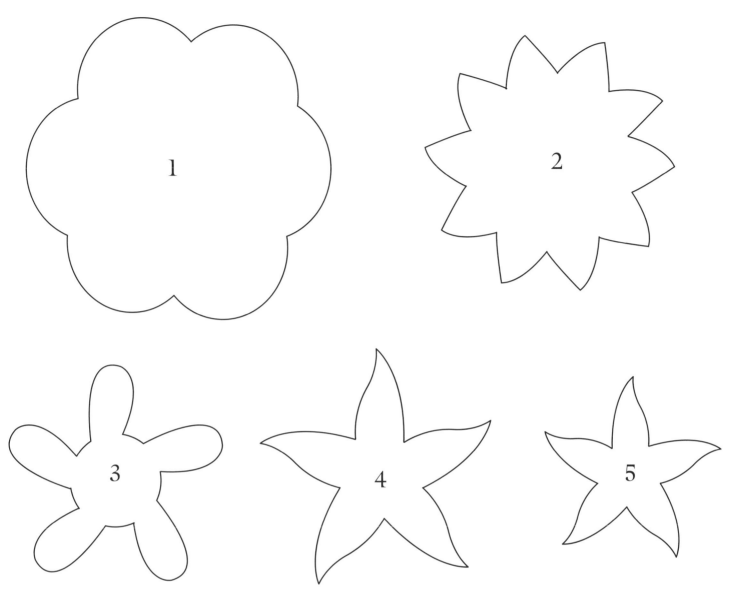

Templates for flower belt (page 48)

Templates for decorating mobile phone case (page 50)